IMAGES
of America

WEST SACRAMENTO

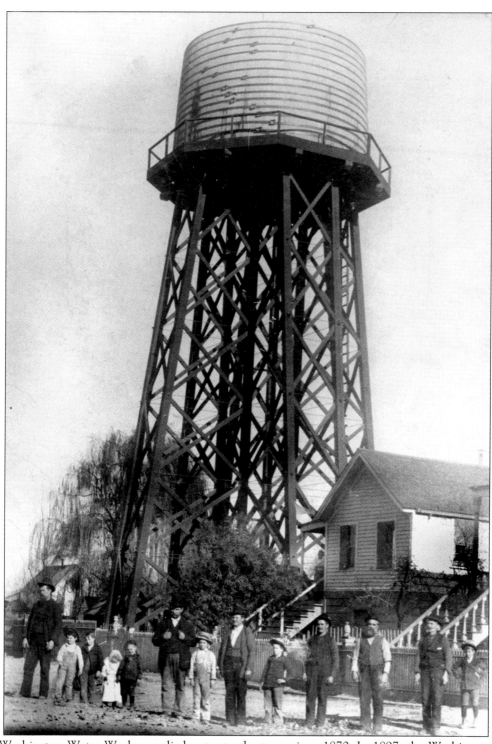

Washington Water Works supplied water to the town since 1870. In 1897, the Washington Water and Light Company incorporated. For 50 years, the company supplied water, lighting, and electricity.

IMAGES
of America

WEST
SACRAMENTO

West Sacramento Historical Society

ARCADIA

Published by Arcadia Publishing
Charleston SC, Chicago IL, Portsmouth NH, San Francisco CA

Printed in Great Britain

Library of Congress Catalog Card Number: 2004111400

For all general information contact Arcadia Publishing at:
Telephone 843-853-2070
Fax 843-853-0044
E-mail sales@arcadiapublishing.com
For customer service and orders:
Toll-Free 1-888-313-2665

Visit us on the internet at http://www.arcadiapublishing.com

(Courtesy of West Sacramento and Byron Miracle, 2002.)

CONTENTS

ACKNOWLEDGMENTS

The West Sacramento Historical Society began as an organization in 1993. From its inception, members began collecting and duplicating photographs to include in their collection. While much remains to be either acquired or duplicated, this book is the result of the efforts by member volunteers Jeri Hughes-Wingfield (photo librarian, text and editing), Mickey Fausett (oral history), Verna Ellis (historian and text), Don Minnich (scanning), Cecilia Vasquez and Louisa R. Vessel (proofing), and Thom Lewis (executive editor).

Although this book is not a complete representation of the communities comprising the City of West Sacramento (Broderick, Bryte, West Sacramento, and Southport), it does illustrate the varied ethnicities and businesses in West Sacramento. Although the city was incorporated in 1987, the original communities have retained their unique identities. Longtime residents always refer to their own community with distinct pride. Today, generations of families live in West Sacramento. This book is dedicated to those families that came before us and made West Sacramento their home.

Several historical reports have been written that document the history of West Sacramento. The authors would like to acknowledge those people who took the time and effort to record this history for future generations. Mr. Julius Feher is the first to be acknowledged. In addition to his efforts as a newspaper writer and editor, Mr. Feher wrote the first published history of West Sacramento. Other historians that followed him were Virginia Weathers, Martin A. Cabalzar, Margaret Landsburg, and Shipley Walters. Without them, the history of West Sacramento may have never been preserved.

Finally, we would like to acknowledge all those individuals and families that have contributed photographs for this book: Louise Vessell, Louisa R. Vessell, Lana Paulhamus, Alma Soust, Jeri Hughes Elliott Wingfield, Louise and Max Hughes, Lester Dotson, Verna Ellis, Bryan Turner, West Sacramento Land Company, Virginia Seamans, Mike McGowen, the Kelly Perini family, Phyllis Runyan, Candace Barry, Margaret Crawford, Kathy Perrigo, City of West Sacramento, California History Section of the California State Library, Yolo County Archives, West Sacramento Police Department, Rusty Mendez, Anna Palamidessi Mesquita, Jackie Lopes Gilmete, Una Hughes Reason, John Bertagna, Joe G. Lopes Jr., Marion Henderson, Virginia TaFoya Lopes, Erleen Carrico Culver, Carylyn Lopes-Rhodes, West Sacramento Fire Department, Ida May Pina King, California Department of Water Resources, the Reuter family, Steve Dupipacly, Marino Pierrucci, Leonard Ortiz, John Siden, and Kathryn Netherton.

Any errors are unintentional.

—Thom Lewis, President
West Sacramento Historical Society, 2004

INTRODUCTION

West Sacramento is in Yolo County, located in the southwestern part of the Sacramento Valley. Bordered by Solano and Napa Counties on the west and the Sacramento River on the east, it is located in the crossroads of California's major highways, railroad lines, and waterways. It is approximately 83 miles east of San Francisco, 136 miles west of Reno, Nevada, 387 miles northwest of Los Angeles, and 288 miles south of the Oregon border. The Southport area of the city is bounded by the Sacramento River and the Sacramento Deep Water Ship Channel.

After several grassroots efforts, the City of West Sacramento was finally incorporated in 1987. The city is 23.3 square miles in size and includes the distinct communities of Broderick, Bryte, West Sacramento, and Southport. Mostly a community of industry and agriculture, the majority of West Sacramento has become a bedroom community for residents working in other towns or counties. Today, the population is around 34,000 and is expected to grow to nearly double that size in the next 20 years.

The early life of West Sacramento and Yolo County began with the Patwin Indians, believed to be the first inhabitants of this area. Later, in 1843 or 1844, the Flemish Jon Lows de Swart, also known as John Schwartz, became the earliest known settler in the West Sacramento area. He built a shack on the west side of the Sacramento River. With the help of John Sutter, Schwartz applied to the Mexican governor, Manuel Micheltorena, for a land grant. This land was located on the west bank of the Sacramento River and was 1 mile wide and 20 miles long. Schwartz named this land (13,000 acres) Nuevo Flandria in honor of his homeland; however, when the United States acquired California, apparently the boundary was too vague and was later rejected by the United States courts.

Despite the vague boundary, Schwartz sold 600 acres of his land at $12.50 per acre to James McDowell in 1846. McDowell was later killed in a barroom brawl in Sacramento, leaving the property to his wife, Margaret. To support her family of five she began taking in boarders. Then in 1850, she had her land surveyed and divided into blocks that designated the township of Washington. The original streets were named after her family members.

In 1851, Margaret married Dr. Enos Taylor and together they sold these city lots. They also provided land for a school and a town hall. Washington became a political and commercial center for Yolo County. From 1850 to 1857, and again from 1860 to 1862, Washington was the county seat for Yolo. Because of the persistent flooding in the valley during winter, the county seat was permanently moved to Woodland in 1862.

From 1864 to 1866, Washington was the riverfront home of the first Pacific Coast Salmon Cannery. By 1880, there were 1,555 residents living in Washington Township. Between 1900 and 1920, the population of what is now the City of West Sacramento included nearly 2,638 inhabitants. Three distinct communities of cultural diversity emerged during this era: Broderick, Riverbank (which became Bryte and then West Sacramento), and Southport. Southport became a separate community after the 1963 completion of the Port of Sacramento that connected to Lake Washington.

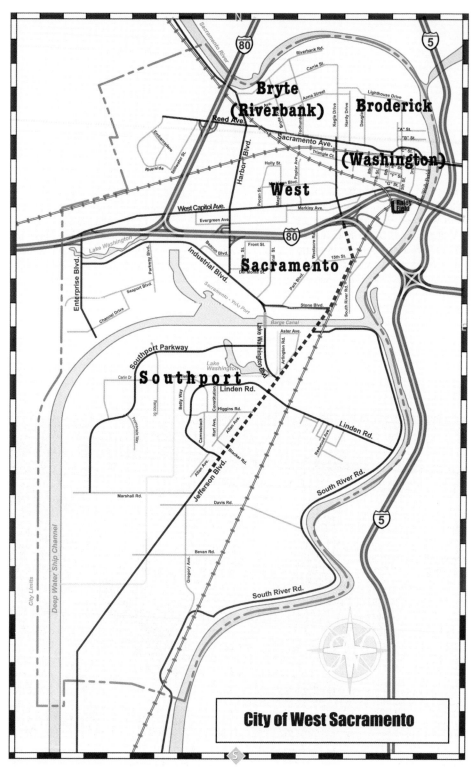

(Courtesy of City of West Sacramento, 2004.)

8

One
EARLY INHABITANTS

The Patwin are believed to be the first known Native American inhabitants of West Sacramento. They belonged to the linguistic group called Penutian, and the Penutian belonged to a larger group, the Southern Winton. The Patwin were a non-agrarian people who lived mostly in the western Sacramento River Valley region; they rarely resided beyond two miles east of the Sacramento River. Their known territory extended along the Sacramento River from Maxwell south to Benicia and San Pablo Bay.

Most villages were located on high ground and near the river and contained dome-shaped lodges constructed of tule and mud. Several Patwin villages are known to have existed in what is now West Sacramento.

Before the first Europeans arrived in Yolo County, the area along the Sacramento River was heavily forested with giant oaks, willows, cottonwoods, alders, sycamores, and thick underbrush growth.

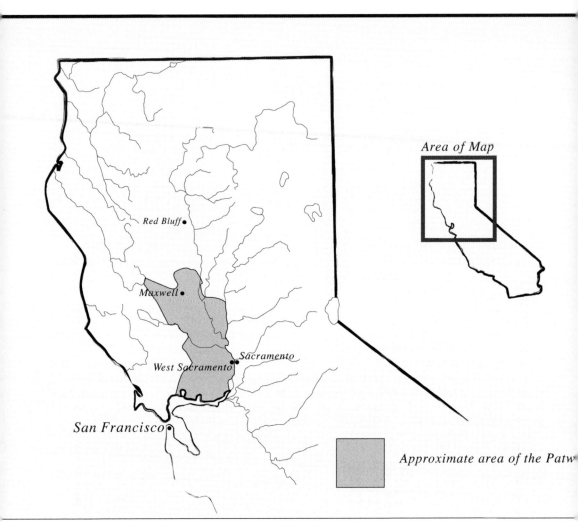

Area of Map

Approximate area of the Patw

This map shows the area of the Patwin culture.

Two

WASHINGTON
TOWNSHIP–BRODERICK

Mrs. Margaret McDowell (Taylor) built a town to purchase a piano. On Washington's Birthday in 1850, she laid out the town and named it Washington to commemorate the American president. What followed was the quick deposit from the first sale to purchase a piano from J.H. Wentworth of Sacramento for her daughter.

The population of this small river town began to grow and four additional buildings were constructed, including the Olive Branch Hotel. Periodic flooding in the area destroyed property and took several lives, and because of these floods, Washington lost the county seat. With the constant flooding, residents had to establish reclamation projects and levees.

As early as 1848 ferries crossed the river from Washington to Sacramento. The first bridge to span the river was built in 1858. Twelve years later the California Pacific Railroad Company took over and began replacing it with a new bridge for rail service. In 1911, a second bridge was constructed, the I Street Bridge, which is still in use in 2004. The M Street Bridge was constructed to carry the Sacramento Northern Railroad and automobile traffic. The Tower Bridge replaced it in 1935.

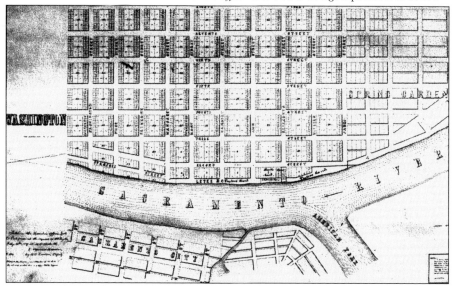

This is a copy of the only remaining plat map of the town of Washington. Margaret McDowell had 600 acres surveyed and divided into a town plat. At that time, only a few residents, including Margaret and her five children, lived in Washington. In 1851, Margaret married Dr. Enos Taylor and together they began to sell city plots. At this time, they also built a city hall and then a school in 1914.

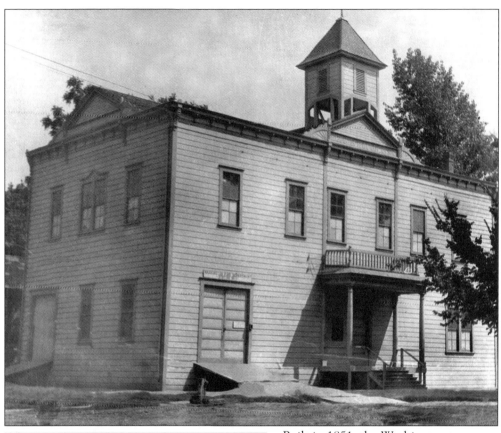

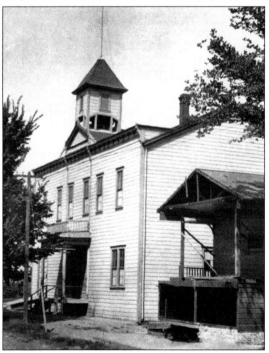

Built in 1851, the Washington town hall, located on what is now Third and C Streets, was the site of the Yolo County seat. Meetings and community events were held here. These pictures were taken in 1917, when the building housed the fire department and the justice court on the ground floor. Upstairs was the town hall auditorium. In the late 1930s, this building was demolished to make room for the art deco–style firehouse that was built with Works Progress Administration (WPA) labor. The wood from the town hall was salvaged and used to build another home in the area.

ADMINISTRATOR'S SALE!!

By virtue of an order of the Probate Court of Yolo County, I will expose to Public Sale, upon the premises,

On TUESDAY, March 4, 1851

At 9 o'clock, A. M.

TWELVE LOTS,
In Range No. 2, and

Twenty Lots,
In Range No. 3,
IN THE TOWN OF WASHINGTON.

F. WOODWARD,
Administrator of James McDowell.

Washington, Yolo County, March 3, 1851.

PLACER TIMES JOB OFFICE.

FACSIMILE OF POSTER, ADVERTISING SALE OF LOTS WHICH ESTABLISHED THE TOWN OF WASHINGTON

This is a facsimile of an 1851 Town of Washington poster advertising an administrator's sale.

Samuel and Mary Conrad were part of one of the first families to move to West Sacramento, settling near the river in 1852. They came to the area after their hotel, the Eagle, burned down in Sacramento.

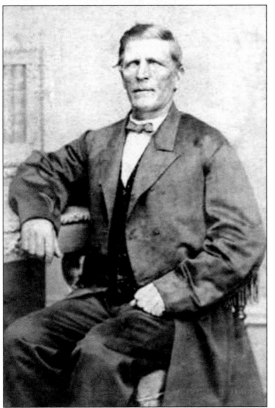

Davis B. Barry moved from Ireland to Washington, settling here when few homes existed on this side of the river. He died June 9, 1888, at the age of 64. He was the father of Judge Jerome Barry and William J. Barry.

This is young Jerome Barry, respected judge of Washington Township. He was born in Washington in 1859, the son of Davis B. Barry and his wife, Margaret. Jerome was a well-known athlete in his youth. He pitched for the Sacramento Atlas team of Sacramento, winning 11 games consecutively. He also held the championship for skiff rowing on the river. He married Annie Fay in 1886. Their children were Judge Davis B. Barry, Jerome D. Barry, Seth G. Barry, Constable Ellis Barry, and Ethel Barry McClure. He died in 1931 at age 72.

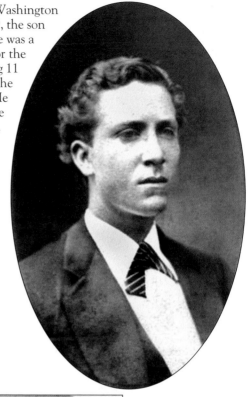

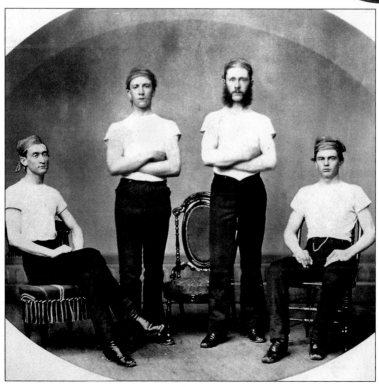

Pictured as part of the Riverside Rowing Club in this 1890s photograph are, from left to right, H.G. Thiele, W.J. Barry, W.A. Butterfield, and Rufus Lowell.

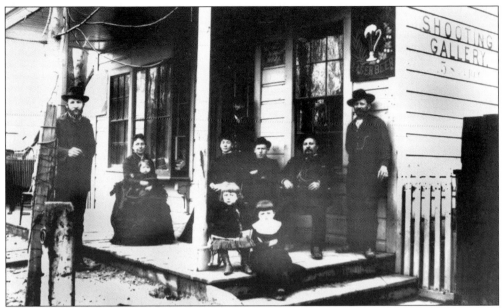

Like the Olive Branch Saloon, the Hoffman Saloon also supplied strong drink at its location on D Street between Second and Third Streets. In the photograph below, Jack Rueter's Barber Shop is visible at the far left.

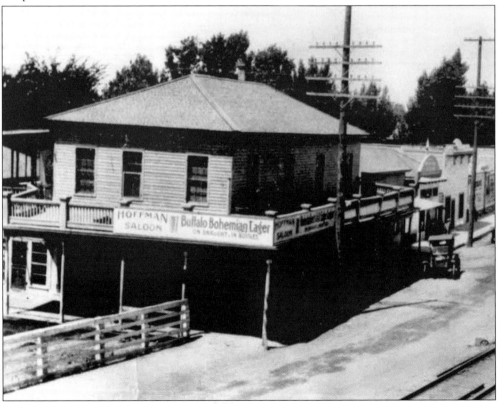

Two hotels, the Olive Branch and the Bridge House, provided meals and rooms. Four saloons, including the Olive Branch Saloon, pictured at right, provided beverages. A man named Byrant built the 22-foot by 32-foot building.

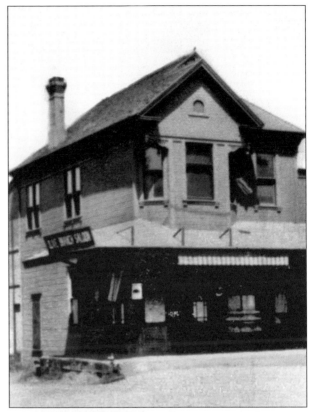

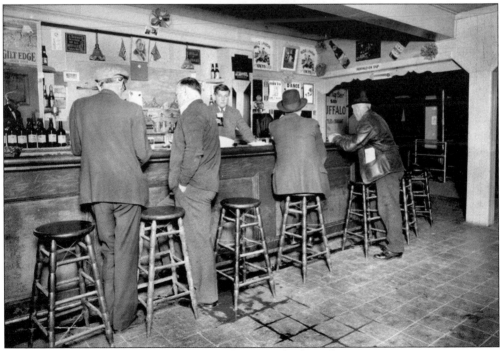

The bar in the Bridge House Inn, pictured here, was built in the 1930s.

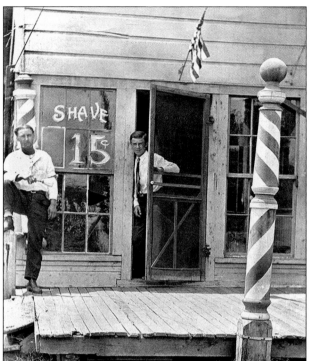

Located on D Street between Second and Third Streets, Rueter's Barber Shop was one of many businesses that thrived in Washington. On the left is Jack Rueter, who served as the county supervisor. On the right, in the doorway, is Steve Dupzyck. The Hoffman Saloon was next door.

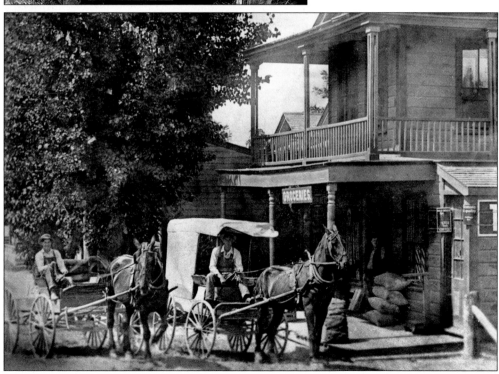

T.J. Cunningham Grocery Store, located at 410 Second Street, served local residents and farmers. Although this photo was taken in 1915, the primary mode of transportation at that time was still the horse-drawn buggy.

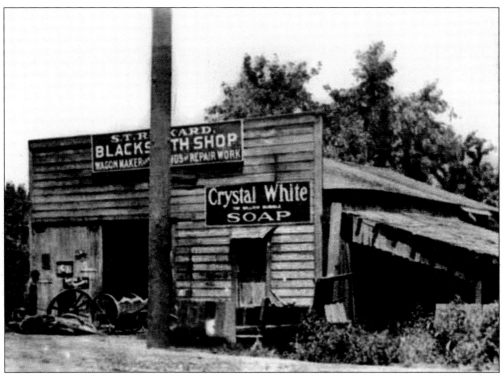

S.T. Richard Blacksmith Shop was the equivalent of the corner garage of today. This photo, taken in 1917, shows the northwest corner of Second and E Streets.

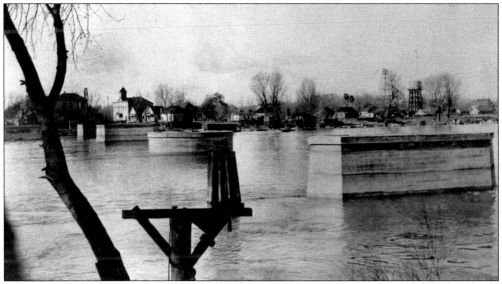

This photo, probably taken during the Southern Pacific Railroad bridge construction over the Sacramento River, shows Washington's waterfront. The center concrete foundation is where the bridge pivots, allowing boats to travel up or down on the river. The Washington town hall building is visible to the left. Most of the buildings in this picture no longer exist; however, the large tower frame on the right is still a local landmark, though it was shortened and now bears the River Walk sign.

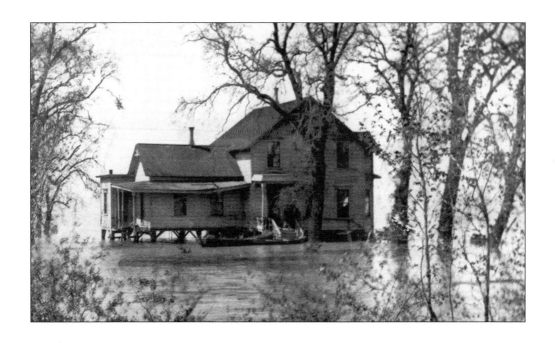

Flooding in the Sacramento Valley was not uncommon. The floods of 1861–1862 convinced both Sacramento City and Washington to build levees for protection. At this time, Sacramento City raised its downtown streets and built levees. Lacking the finances, Washington was unable to provide such protection. The county seat was moved from Washington to Cacheville, then finally to Woodland.

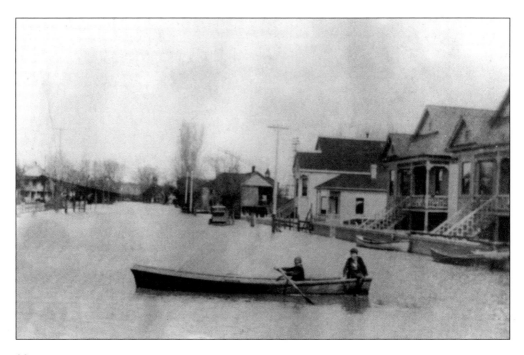

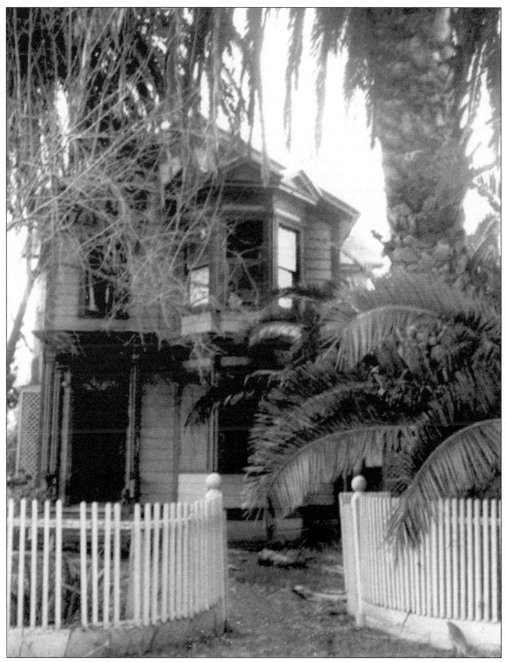

John White and his son Fred built this two-story structure around 1868. Known today as the White House, it was originally built on a levee. During one of the frequent winter storm floods, it was washed off the levee to its site at 610 Second Street. It was demolished in 1986.

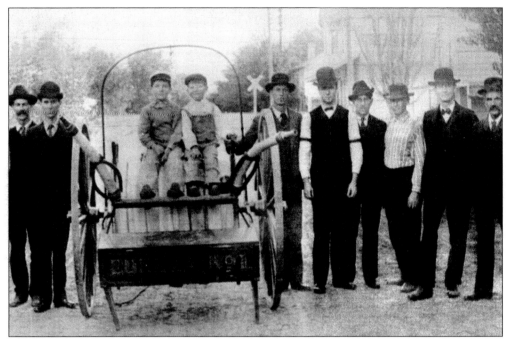

This 1909 photograph, taken on E Street and looking toward Second Street, shows what is probably Washington's first all-volunteer fire department. The pull-hose cart shown is typical of the early 1900s. When the bell rang from the town hall building, the volunteers would stop what they were doing and respond to the alarm. Standing, from left to right, are Henry Buckingham, R. Steuben, unidentified, Bob White, Tom Evans, Steuben Sanford, Frank Di Riso Sr., and Tom Burns. The two seated children are Seth (left) and Jerome Barry. Jerome later became the first judge in Yolo County.

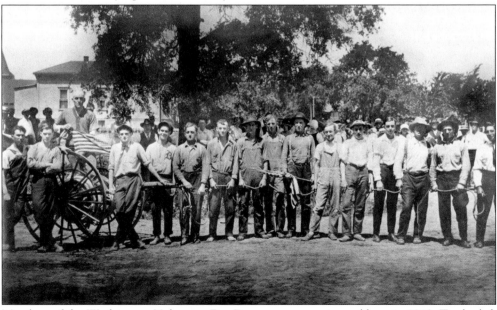

Members of the Washington Volunteer Fire Department are pictured here in 1918. To the left of the volunteers is the Washington Town Hall building.

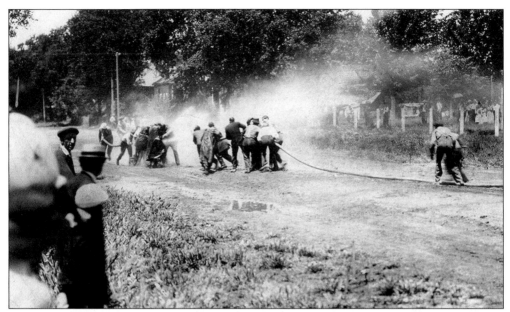

Firefighting teams from Sacramento came to Washington to compete against the East Yolo team. These timed competitions became a popular spectator sport that included family picnics in the early 1900s.

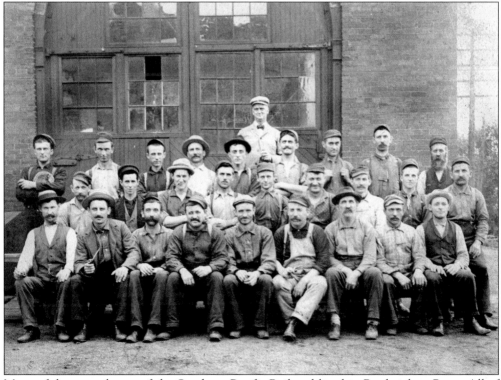

Many of these employees of the Southern Pacific Railroad lived in Broderick or Bryte. All of the volunteer-built fire trucks were made of salvaged parts from the Southern Pacific maintenance yard in Sacramento.

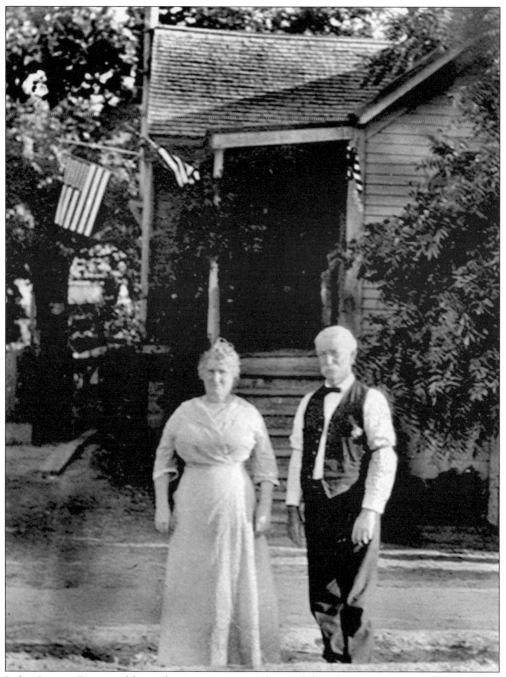

Judge Jerome Barry and his wife, Annie, pose in front of their home at 325 Ann Street (now 325 D Street) on July 4, 1916.

This steam train is travelling east over the I Street Bridge. Residents of Washington saw growth in their town wither after this bridge was built. There was no longer a need to stop in Washington to arrange ferry passage as in earlier times.

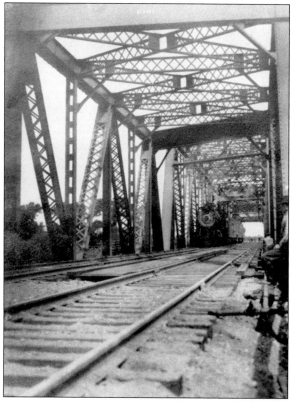

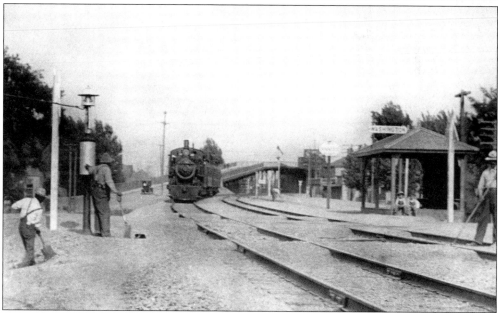

Trains often carried cargo and passengers through Washington. Here a Southern Pacific train heads west through Washington near Fourth and D Streets. Several railroads came through West Sacramento, including the Sacramento Northern, California Pacific, Sacramento-Woodland, Northern Electric, Western Pacific, and the Sacramento Short Line.

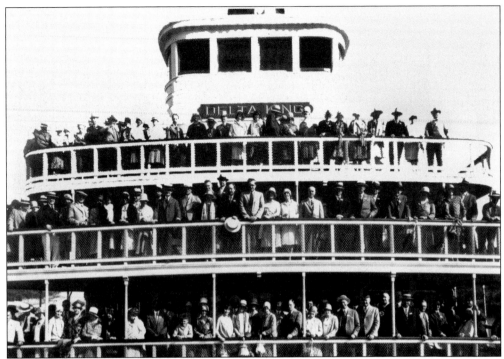

The famed riverboat, the *Delta King*, is pictured here with many passengers. Built in the 1920s, the Delta King operated on the Sacramento River, carrying passengers and cargo between Sacramento and San Francisco. These photos were both probably taken in the 1930s.

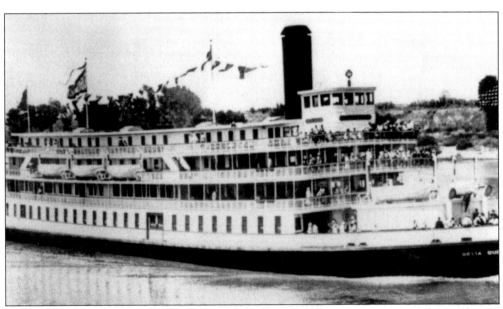

During the 1920s, both the *Delta King* and the *Delta Queen* ferried passengers and cargo to and from the Bay Area. While one boat sailed from Sacramento, the other would start its trip up the Sacramento River from San Francisco. The California Transportation Company operated both boats.

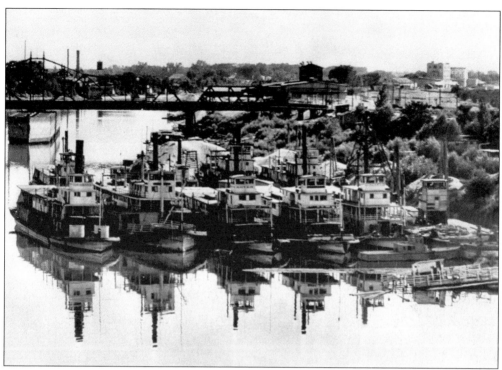

Riverboats, like these in 1931, moored in the Sacramento River at Broderick. The Tower Bridge replaced the M Street Bridge, in the background, in 1935. The California State Rice Milling Company is visible in the upper right.

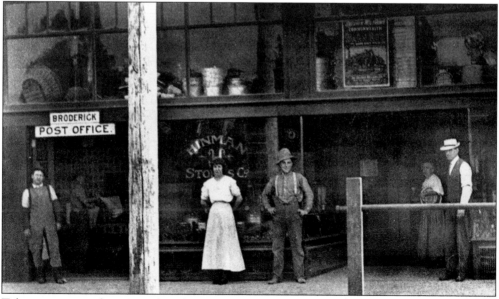

Taken sometime after 1914, this photograph shows an early post office and the Hinman Store in Broderick.

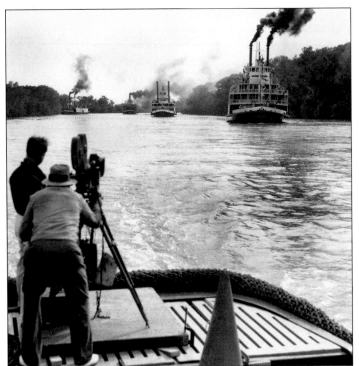

Steamboat races were popular in the 1930s. This type of race, being filmed in 1935, was quite common on the river; however, races could become hazardous to the crew and passengers when boilers blew up from overheating.

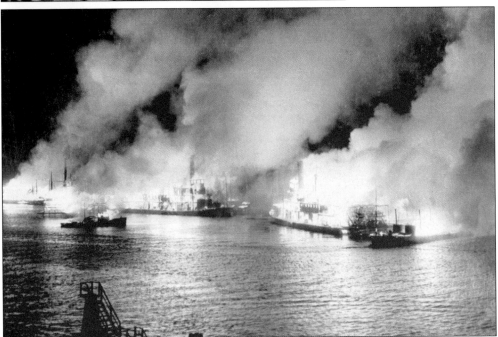

During the 1920s, the Sacramento Navigational Company shipyards were busy with the repairing and overhauling of vessels. In 1922, the Broderick shipyard employed up to 40 employees. A suspicious and disastrous fire that broke out on August 28, 1932, destroyed 13 riverboats and barges. The fire began with an explosion and flames quickly spread from one wooden vessel to the other.

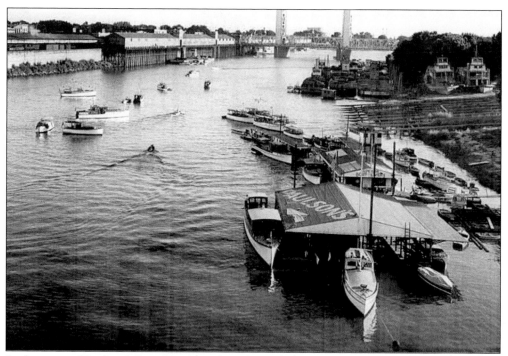

In this view of Paulson's Boat Works and Docks in the mid-1930s, notice the wooden skids on the upper right for hauling riverboats to and from the river for repairs.

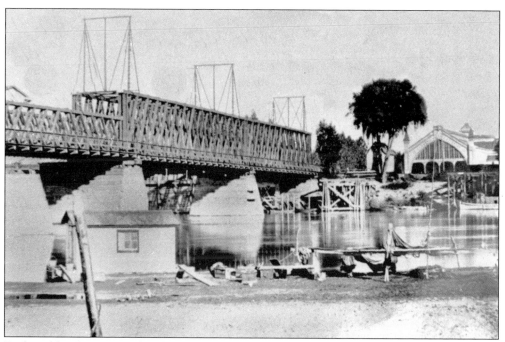

Bridges, like this one, replaced ferry boats that operated from both shores of the river. This is most likely the Southern Pacific Railroad Bridge.

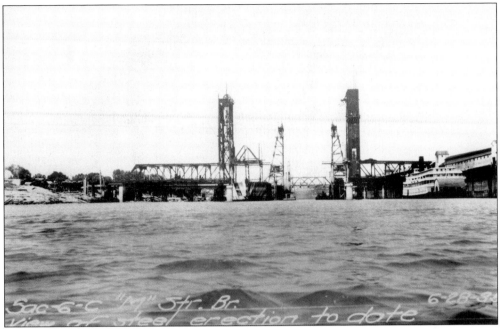

In 1935, the Tower Bridge replaced the original M Street Bridge. Looking north, Broderick (Washington) is on the left and Sacramento is on the right. At right, a steamer, possibly the *Delta King*, is moored at the California Transportation Company dock.

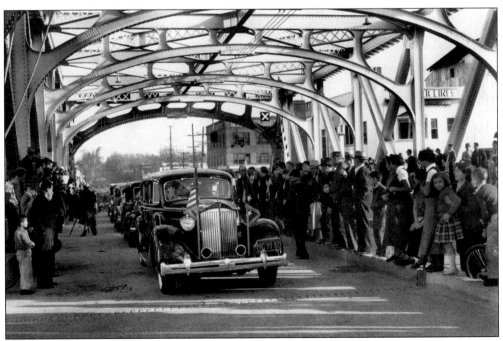

This photo, taken on the Yolo County side facing east towards Sacramento, shows the 1935 celebration of the opening of Tower Bridge.

In 1856, the Washington Public School District, the third such school district in the county, was organized. Dr. and Mrs. Enos Taylor donated the property for the new school. It was located on two lots on Elizabeth Street, which today is C Street (it is actually located at Third and C Streets). Two more schools were added in the area—the Monument Bend School (November 5, 1861) and the Sacramento River School (November 7, 1864). In 1917, residents built this new Washington Grammar School. It was finally closed in the 1950s and used as Yolo County's Salud Health Clinic.

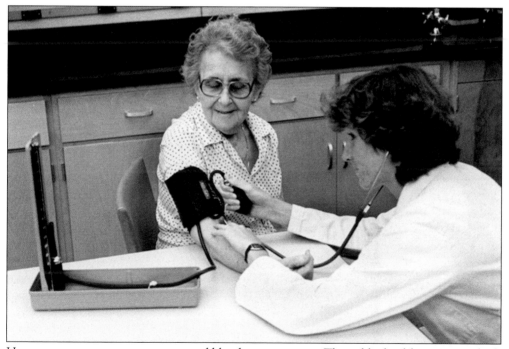

Here a woman gets a county-sponsored blood pressure exam. The public health program, which began in 1994, was accessible at Salud Clinic, now the site of the new Metro Place at Washington Square.

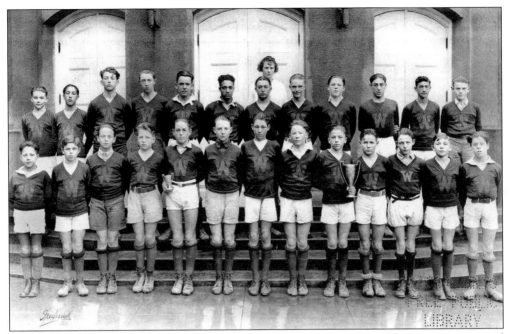

Sport activities in the school district involved organized soccer teams. This team represented Washington Elementary School, c. 1920.

This photo may have been taken between 1880 and 1900 and shows the Dame School.

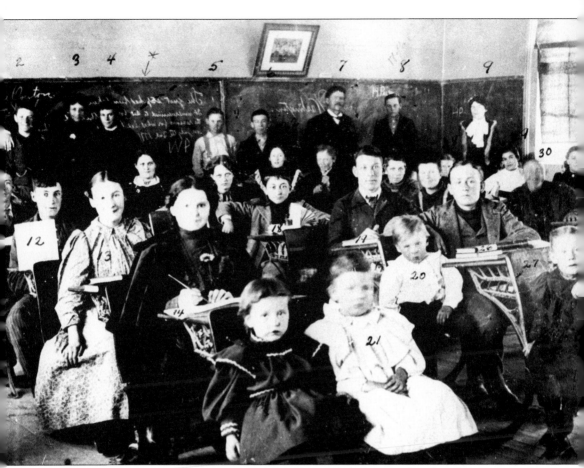

This is an 1898 one-room classroom in Washington. T.J. Goen, number 7 in the picture, was both the principal and teacher of the school. There were 64 students between the ages of 4 and 18, 11 of whom were orphans.

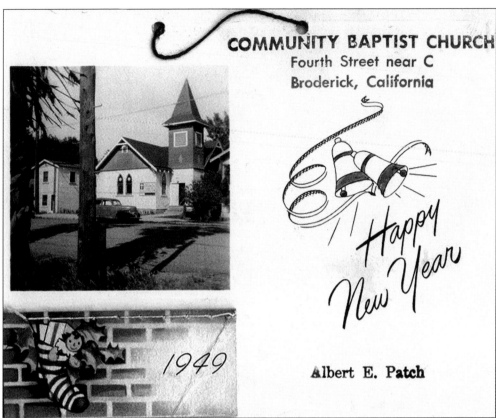

COMMUNITY BAPTIST CHURCH
Fourth Street near C
Broderick, California

Happy New Year

1949

Albert E. Patch

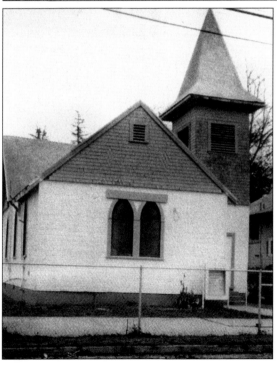

The Community Baptist Church, pictured on the 1949 calendar above and at left, was built by Protestants on Fourth Street in 1915. In 1950, many families moved into newer subdivisions and church membership diminished. In 1955, a new Baptist church was built at Sixth and Andrew Streets. The Fourth Street building was later used by another Christian denomination. The church was destroyed by fire in 2002.

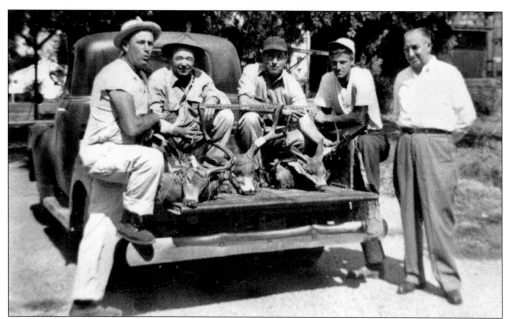

This photo of successful hunters posing with a deer was taken at the Casselman ranch near Monument. Pictured, from left to right, are unidentified, Palmer de Barry, unidentified, Ray Casselman, and Carl Casselman.

The WPA constructed this building for the Washington Fire Department in the late 1930s. Not only did it serve as a fire station, but it also housed a community center on the second floor. After the fire department merged with the West Sacramento Fire Department, the Yolo County Sheriffs Department and the West Sacramento Police Department used the building to store evidence material. It was saved from demolition in 1997. The building is pictured here sometime after 1955.

Located on parcel number 54 on Joan Street off Kegle, this track home is being built in the late 1950s as part of a Broderick subdivision. It faces north towards the Sacramento River at the tree line. This area was once a prune orchard

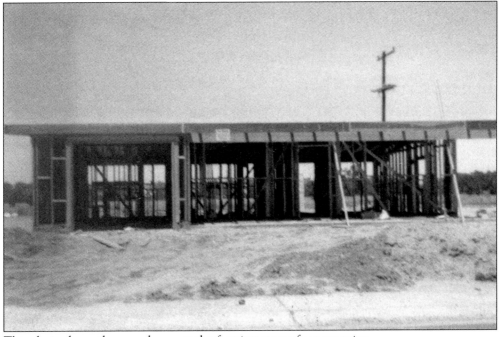

This photo shows the same house at the framing stage of construction.

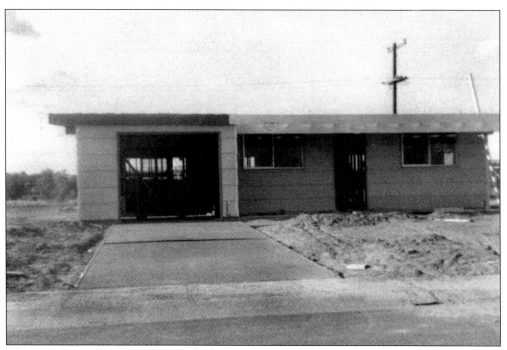

The same house now has siding applied to it.

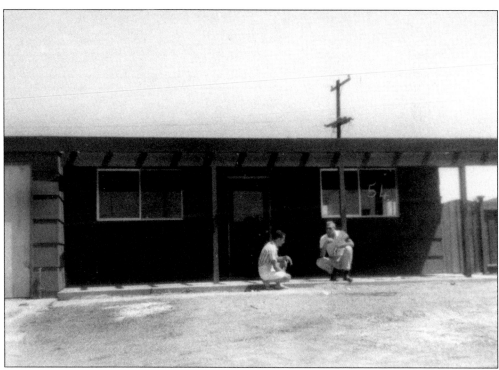

Now completed, the home remains occupied by the original owner. It is not uncommon to have several generations of a family living in the same neighborhood, or to have a home transferred to family members.

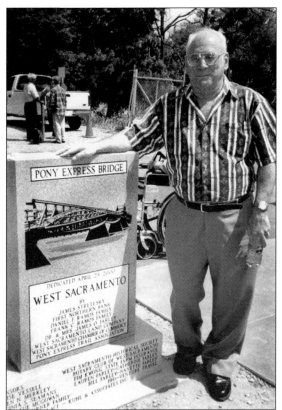

Past city council member and mayor of West Sacramento, Ray Jones attends the dedication of the Pony Express Bridge monument. The October 22, 2000 event was to commemorate the Pony Express stop on the west side of the Sacramento River. This monument was dedicated to the memory of the 20 rides made by Pony Express riders to deliver mail to San Francisco. The riders normally ended their east-to-west delivery route in Sacramento, where it continued aboard a steamship. However, when riders arrived too late for the ship, they continued across the wooden spring bridge at the location of today's I Street Bridge, through West Sacramento, and on to San Francisco.

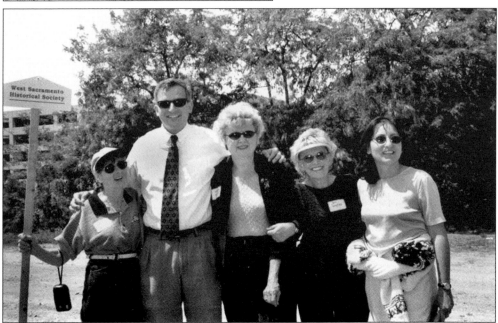

Some members of the West Sacramento Historical attending the Pony Express dedication along with Jon Robinson of the City of West Sacramento (second from left) are, from right to left, Verna Ellis, Louisa R. Vessell, Jerry Hughes-Wingfield, and Cecilia Vasquez.

Three

BRYTE

Bryte began in 1912 as the settlement of Riverbank. It was named after George Bryte Sr., a local dairyman and the son of Mike Bryte, a pioneer dairyman. He later sold his and his two sisters' interest to the West Sacramento Company for residential purposes. Conditions of the sale required that the area carry the name of Bryte and that a street must carry each of the names of the sellers.

The physical, developmental, and social characteristics of Broderick and Bryte were distinctive. Early residences in Broderick were designed to accommodate periodic flooding through the elevation of their living quarters. In Bryte, construction followed reclamation projects that resulted in one-story homes with different architectural styles.

The D.W. Hobson Company was the original subdivider of Riverbank. To entice customers to the area, developers would provide free transportation to the site, refreshments, and "easy terms," such as nothing down and payments of $7.50 per month. Bryte developed into the largest Russian settlement north of San Francisco. Another group that settled in Bryte were the Portuguese, and Japanese farmers worked on many of the small farms that dotted the area.

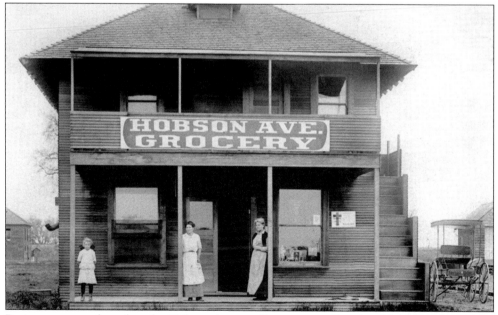

Business was conducted at the Hobson Avenue Grocery near Riverbend by Mary Conrad for several years. Howard Lee purchased the store in 1924, and he lived over the store premises with his family. This photo was taken around 1880.

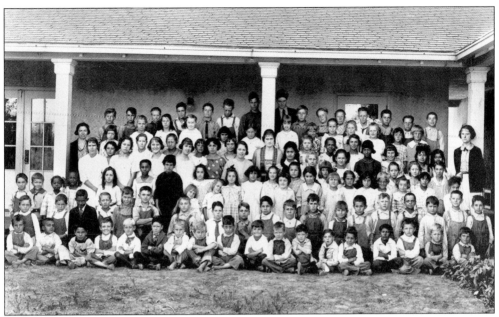

This is a 1921 class photograph from Riverbank School.

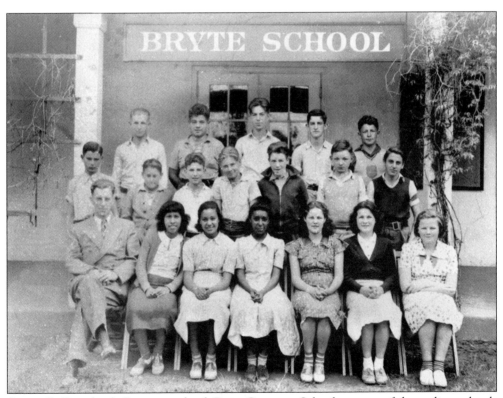

Originally Riverbank Grammar school, Bryte Grammar School was one of the earliest schools in East Yolo. Alyce Norman taught and was principal here for nearly 40 years beginning around 1915. The building is now home to Bryte Apartments.

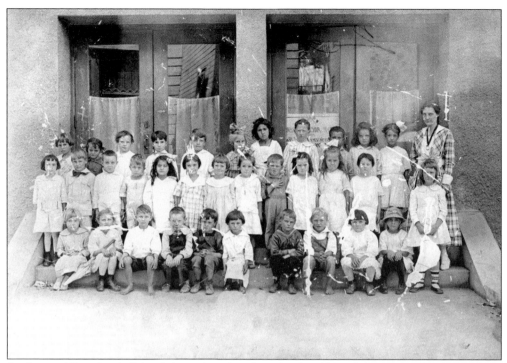

Students of Riverbank School dressed in their best for this 1921 class picture. This school was built in 1915–1916 on Lisbon Avenue. Before attending this school, students attended Washington Elementary in Washington.

This is another class picture from Bryte School. Prior to 1951, the school was named after Alyce Norman. Joanne (Marston) Fausett is in the second row, second from left.

Even after the automobile became popular, horse-drawn wagons and buggies were still common in the community and used for farming.

Pictured on the left is Vera (Verasoff) Rasmusson with her mother, Maria Verasoff, in front of their home on Yolo Street in Bryte. The Catholic church at the corner of Yolo and Hobson Streets can be seen in the background.

Horse and buggies were a common mode of transportation at the beginning of the 20th century.

Hunting was also a popular activity in the 1920s and 1930s. Note the flowers in the barrel of her rifle.

Although her name is unknown to us, this elegant woman posing for a formal portrait was a relative of Mike Bryte and his wife, Elizabeth Scnaat.

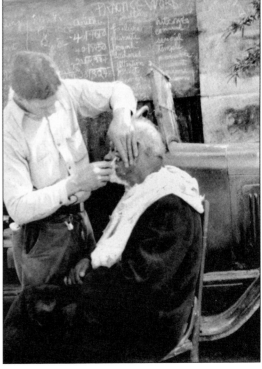

Pictured in this barbershop and classroom, located in a garage in Bryte, are Philip Gonzales and Lee Barro Rodrigues (getting shaved). Gonzales volunteered to teach English to immigrant children and adults in 1900. Note the blackboard in background.

Agricultural products were a typical commodity in East Yolo, and this picture could have been taken anywhere in the West Sacramento area, c. 1913.

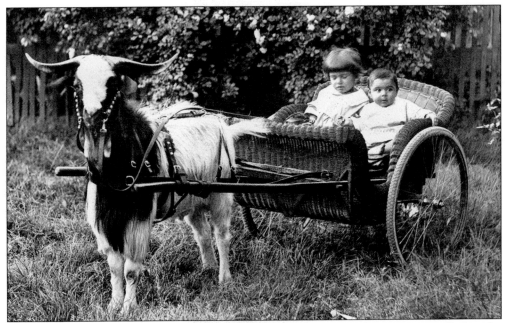

These children had their picture taken by a traveling photographer. For a small fee, the photographer would provide the goat and wicker cart as props.

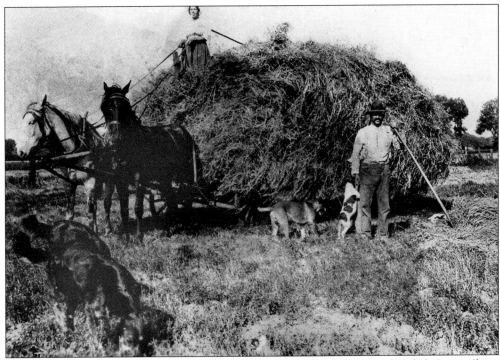

Frank and Carolyn Bertagna are harvesting near Sacramento Avenue and Eighth Street (later Elkhorn Village) in the 1920s.

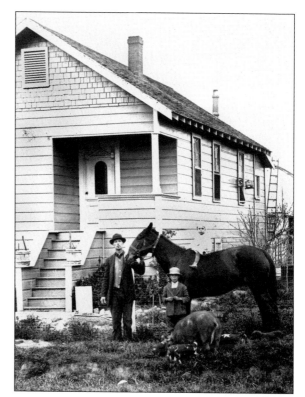

Typical houses during this time had two stories. Since much of West Sacramento was subject to flooding, families often lived in the top floors.

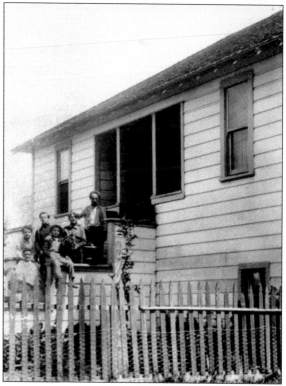

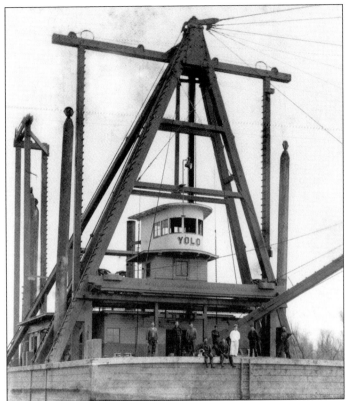

Flooding was always a problem in East Yolo, but it wasn't until the 1860s, when funds became available, that dredging began to raise the levees along the Sacramento River. Pictured here is the dredger, *Yolo*. In 1911, funds became available for dredging in East Yolo. Dredging continues today.

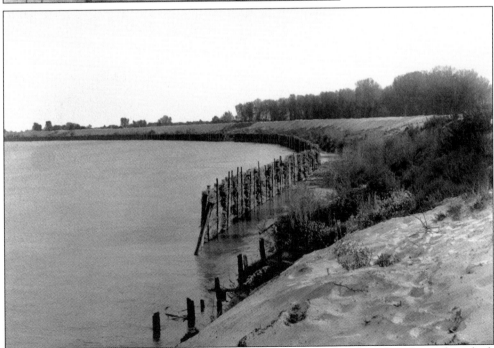

To help stabilize the riverbank and levee from erosion, walls of steel and wooden-plank retaining walls were anchored to the river bedrock.

This photo, taken in the late 1800s, shows a grandmother with her grandchildren and their dog.

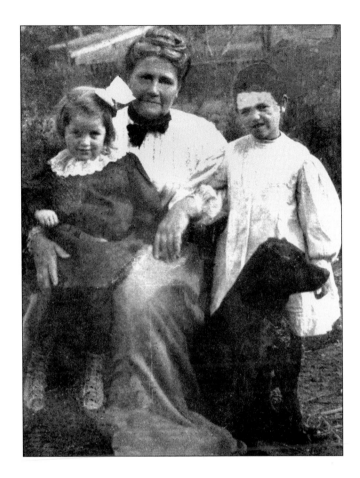

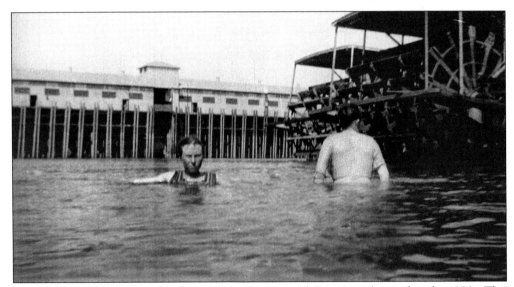

This photo was taken near the Sacramento Navigational Company shipyard in the 1920s. This was an active waterway and boats were usually coming and going, making swimming hazardous.

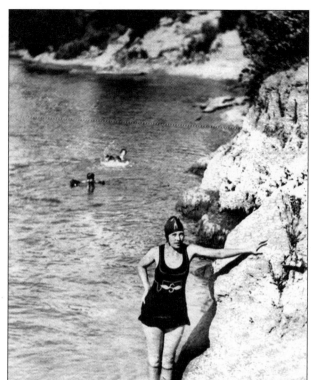

The swimmers in this photograph are probably near River Bend. Families enjoyed spending hot summer days in the water and having picnics nearby.

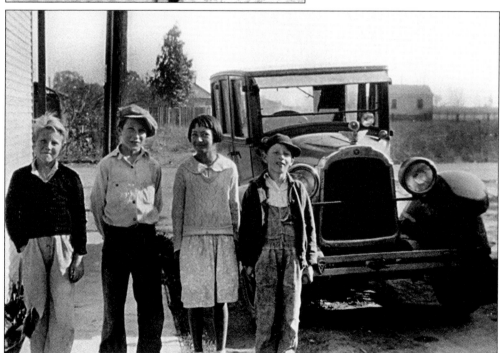

In this c. 1930 picture of the Dotson children and their friends, standing next to the family automobile, Lester Dotson appears on the left. He later became fire chief for the Bryte Volunteer Fire Department.

A young man
sits and rests
while working
in the fields
near Bryte.

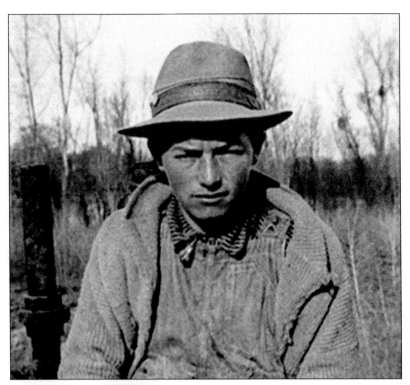

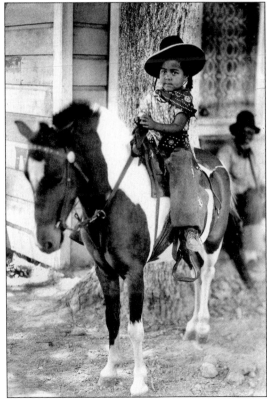

Barbara Andrade sits on a pony while
being carefully supervised by Lee Barro
Rodriques in the background. Both the
Andrade and Rodriques families live in
Bryte today.

Holy Myrrhbearing Women Orthodox Church

Seventy-Fifth Anniversary
1925-2000

The Holy Myrrhbearing Women Orthodox Church, which was built by parishioners in 1925, celebrated its 75th anniversary in 2000. The church, located on Water Street, was enhanced by a cupola of Byzantine design and was one of the earliest churches in Bryte. The design is typical of churches in small Russian villages. The success of the church is attributed to its dynamic parishioners and strong finances. It must be noted that the women of the church laid the foundation for construction of the church.

The Kelley Grocery market was popular from the 1930s through the 1950s.

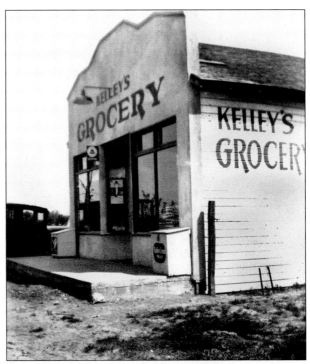

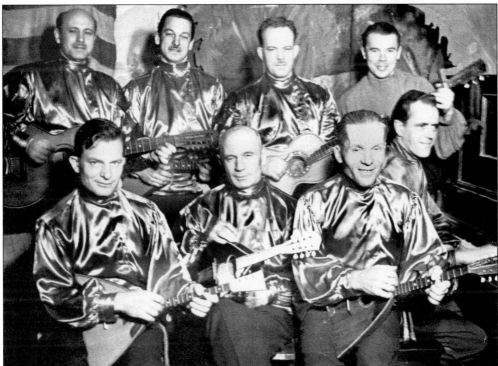

Roman Veselovzorov plays the piano in this Russian orchestral group in Bryte and is joined in this picture by A.C. Ridge, M. Buykoff, Constantine Iverson, Sergei Iverson, and Constantin Ross.

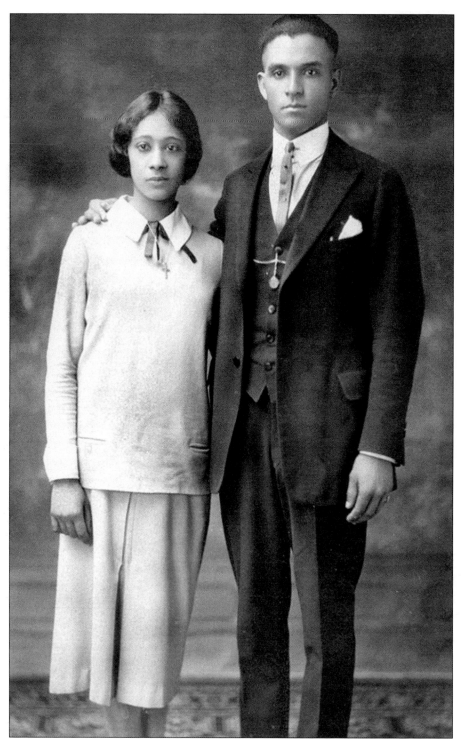

This studio photograph of Jose G. Lopes Sr. and Louisa Rodriques was taken in the 1930s. They were members of the large group of Portuguese who settled in the Bryte area. Their families came from the Island of Fogo in the Cape Verde Islands.

Jose G. Lopes, his wife, Louisa, of Bryte, and a friend are pictured here in the 1940s.

Bryte, like most of West Sacramento and Yolo County, had its share of young men serving in the military. This is an unidentified artillery soldier from the 1920s.

Raymond "Ramon" Vessell (whose Russian name was Ramon Veselovzorov) came to America in the 1920s from Harbin, China, and settled in Bryte and Broderick. He enlisted in the Seabees at the beginning of World War II.

The community and volunteer firefighters built most of the early fire engines for West Sacramento. This engine, known as "Lizzie," was the first volunteer fire engine built in Bryte and was constructed in 1937 on a 1935 Chevy chassis. The parts came from the Southern Pacific rail yard in Sacramento—in fact, she was built from so many locomotive parts that it was said, "When a train whistle blew, she would stand to attention."

An unidentified boy is pictured with his pet calf in the late 1920s or early 1930s. At one time, Bryte was a dairy town and provided milk to the surrounding area.

These large onions were grown in the rich soil of West Sacramento. This unidentified gardener proudly displays his produce.

This landmark building was owned by "Pappy" Ramos. In the 1930s it was used as a theater and was later donated to the VFW in the late 1940s or early 1950s. The local VFW was organized by a group of veterans, including George Kristoff.

Four
WEST SACRAMENTO

West Sacramento began as a visionary project of the West Sacramento Land Company to lure Sacramento residents across the river into Yolo County. The original plan was to build a city like Paris on the west bank of the Sacramento River. In conjunction with this project, there was an electric streetcar service, which ran every five minutes between downtown Sacramento and the subdivision of West Sacramento for the cost of a nickel. Many did come, and a downtown area was developed on Fifteenth and Netherlands Boulevard (now Jefferson Boulevard) that included a grocery store, the West Sacramento Land Company headquarters, a post office, a branch of the Yolo County Library, dry cleaners, a restaurant, a stationery store, a hardware store, and manufacturing businesses.

Another business area developed on Davis Highway (U.S. Highway 40), now West Capitol Avenue, to serve travelers going to and from Sacramento. In the 1960s the development of West Sacramento was negatively impacted when Freeway 50 bypassed the area and took away the "West Sacramento Gateway" to the capital city.

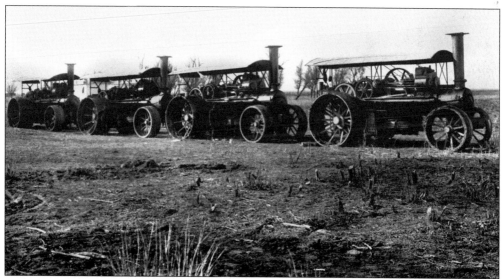

Huge steam-traction engines of this kind were used by the West Sacramento Company to change the landscape of the natural environment. According to historian Shipley Walters, thousands of acres of tules, thick forest growths, cottonwoods, willow, and often great oaks were cleared for the development of the project.

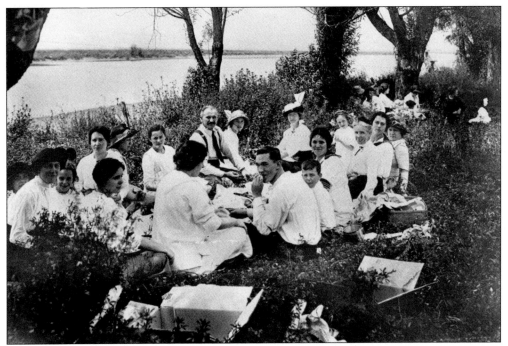

This group enjoys a picnic at Lake Washington, one of the special features of West Sacramento, in 1913. The West Sacramento Company's fleet of limousines carried prospective buyers on tours of the sites to show them the joy of fresh air, sunshine, fishing, boating, and all the healthy benefits of making a home in West Sacramento.

This peaceful scene on Lake Washington illustrates the value of living in West Sacramento and commuting a short distance to work in Sacramento on convenient electric trains with several stations throughout the area.

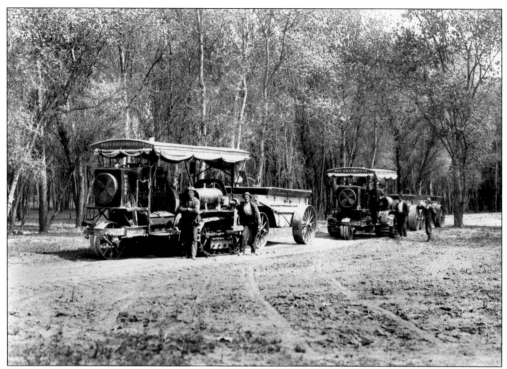

These gas-powered Holt tractors pulled trailers to carry heavy loads. Their low engine numbers indicate that these machines were new models, probably made in 1911 or 1912. The West Sacramento Company proudly displayed its ownership on the shade canopies.

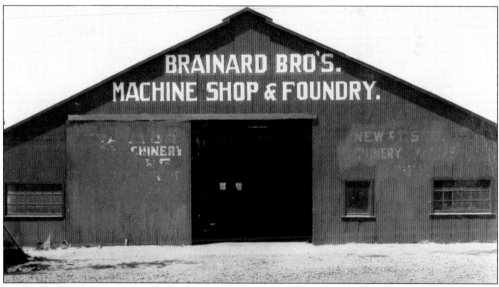

Brainard Brother's Machine Shop and Foundry was located on Davis Highway, now West Capitol Avenue, in the 1930s to the 1950s. It provided machine repairs, fabrications, and other metal-related services for local residents, farmers, and businesses, saving them from having to make time-consuming trips to Sacramento.

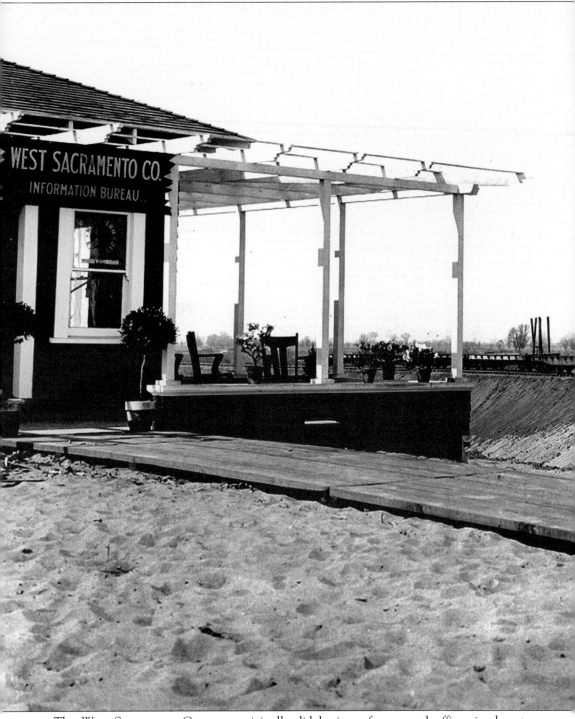

The West Sacramento Company originally did business from grand offices in downtown Sacramento, but moved to this modest structure in 1911 to be closer to the development. Soon,

new headquarters were under construction at the corner of Fifteenth Street and Netherlands Boulevard (now Jefferson Boulevard), which was directly across from the electric-train station.

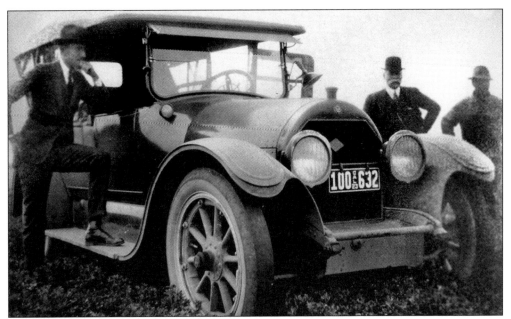

The West Sacramento Company used chauffeur-driven limousines to carry prospective buyers to West Sacramento beginning in 1912.

The Kripps House, named after owners Fred and Margaret (Conrad) Kripp, was located on the levee east of South River Road at the end of Fifteenth Street. Fred and Margaret were married around 1869. After moving into the house, he was involved in a variety of businesses, most notably, as the manager of Snowpark Park on Twenty-ninth and R Streets in Sacramento in 1890. He also built Buffalo Park on Eleventh and Y Streets in 1910. The West Sacramento Land Company later used the house as its first office building. The building was later destroyed.

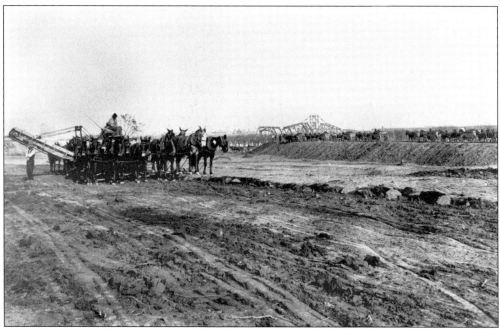

Early 1900s teams of horses and mules dig up soil using a special device and load it into wagons using conveyor belts. Horse-drawn wagons, seen in the background, carried the loads to where they were needed for building up levees, thus protecting the new town of West Sacramento from yearly flooding by the Sacramento River. An almost continuous stream of working teams can be seen atop the levee, with the M Street Bridge in the background.

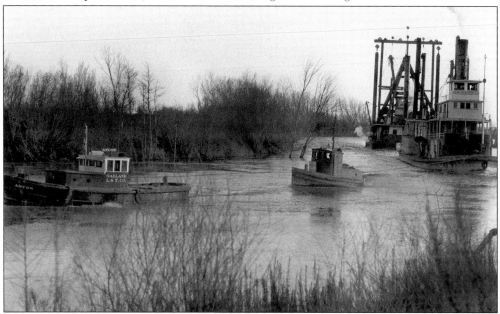

Dredgers like this one worked in the river digging up the shallow bottom and depositing the sand onto the levees to strengthen the levees and to deepen the river bottom. Dredging was another effort to contain the river within its banks and to protect the new town from flooding. This dredger is being towed to a new location by a paddle-wheel steamboat.

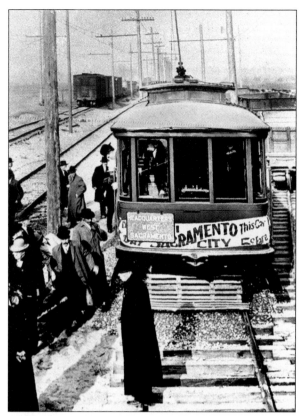

An electric train system was built by the West Sacramento Company to quickly transport its new homeowners back and forth between Sacramento and the healthful country living offered in West Sacramento. These trains ran on convenient schedules and cost only 5¢. The train at this stop near the M Street Bridge was a popular one.

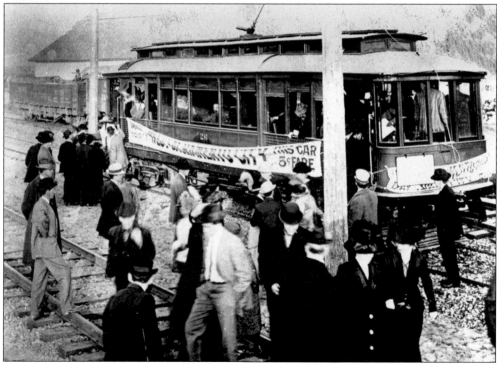

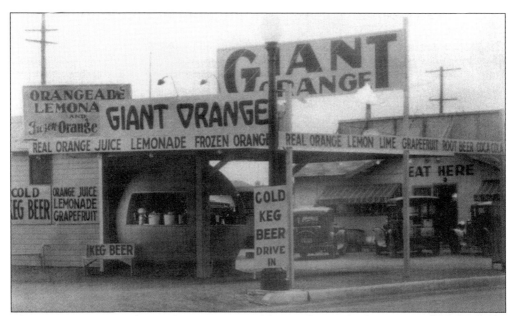

The Giant Orange stand was a favorite stop on Davis Highway, also known as Lincoln Highway and Highway 40. It served refreshments of all kinds to automobile travelers until the late 1940s.

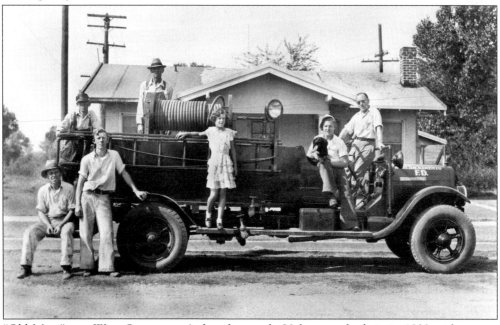

"Old Mary" was West Sacramento's first fire truck. Volunteers built it in 1933 with money raised by subscriptions for fire protection and from a bazaar held by the ladies of the community, lead by Peggy (Mrs. Moe) Reynolds and Jennie (Mrs. Eric) Hughes. Some of the volunteers are shown here with Old Mary on Virginia Street. From left to right are Carl Effenberg, unidentified, Berken Reynolds, Moe Reynolds, Max Hughes, and Eric Hughes, with Una Hughes posing on the running board. Eric, first, and then Max served as volunteer fire chief. There were no hydrants in West Sacramento at that time, so the truck's water tank was kept filled, and a reserve tank of water went along to refill Old Mary at the scene of a fire.

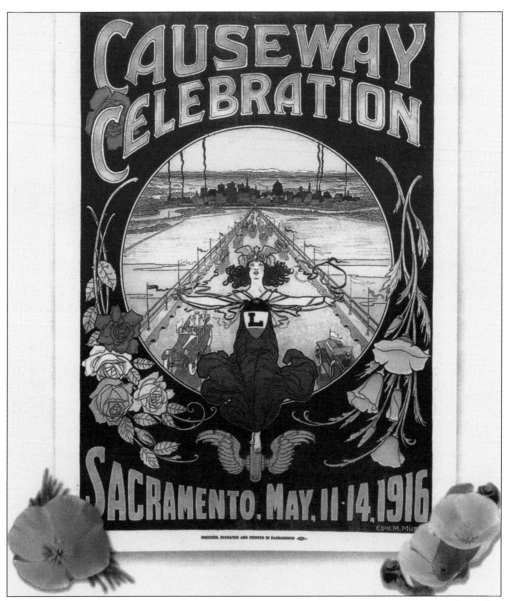

When the long-awaited bridge across the Yolo bypass was opened on May 11, 1916, a three-day celebration was held because, finally, a very undependable 3.5-mile portion of the Lincoln Highway had been replaced by this modern span. This colorful poster, announcing the event, shows Sacramento in the background. The "L" on the model's bodice stands for Lincoln Highway.

The West Sacramento Company constructed this prominent building as its headquarters in 1913, just across the street from the electric train station at Jefferson Boulevard and Fifteenth Street. The post office and a branch of the Yolo County Public Library shared space there. This lovely sight welcomed visitors and residents to the new town. Businesses soon opened in the neighborhood and a real community feeling developed.

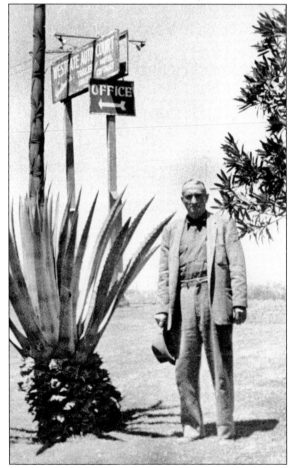

Emil Schaffnit is pictured beneath the sign on South River Road that advertises his Westgate Auto Court and Trailer Park. The premises also offered groceries and gasoline for sale. Many local workers lived there and suffered from rice dust pollution caused by the operation across the road. Rice Growers eventually bought and closed down Westgate in 1974, when they were unable to adequately clean up the pollution in the area.

This *c.* 1911 view, facing west from the corner of Fifteenth Street and Netherlands Boulevard (Jefferson), shows the first phase of the town's development. Many beautiful oak trees were saved during clearing for their beauty and to shade the homes that would soon be built.

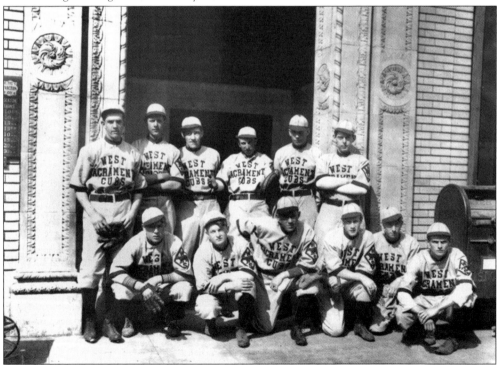

The West Sacramento Cubs are photographed in front of the West Sacramento Land Company office, *c.* 1915. Pictured, from left to right, are the following: (front row) Robert Clifton, Almer Norton, unidentified, Ray Peek, Archie Lewis, and unidentified; (back row) Reese Peck, unidentified, Ernest (Fish) Curry, Ray Speicer, and two unidentified men.

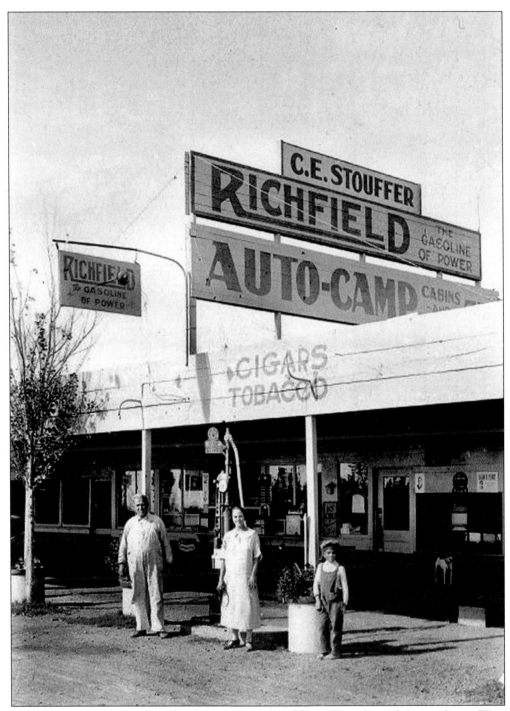

The Carrico family owned this business on Davis Road (now West Capitol Avenue) near West Acres Road beginning in 1922. There were only four other families living on Davis Road at that time. The business offered gasoline, auto camping, cabins, and groceries to tourists and residents. Many such businesses were kept busy when this was the main highway across the United States, also called Lincoln Highway and U.S. Highway 40.

Jacob (Jack) Augster, born in Switzerland in 1867, came to West Sacramento about 1920 and built a boathouse on pilings, one block north of Linden Road. He was a commercial fisherman, rented boats, and raised Bantam chickens for sale. He married in 1928 and, at age 63, fathered Katherine, Jack, and Mary. The family lost everything when their house slid into the river on February 14, 1940. Augster died in January 1952.

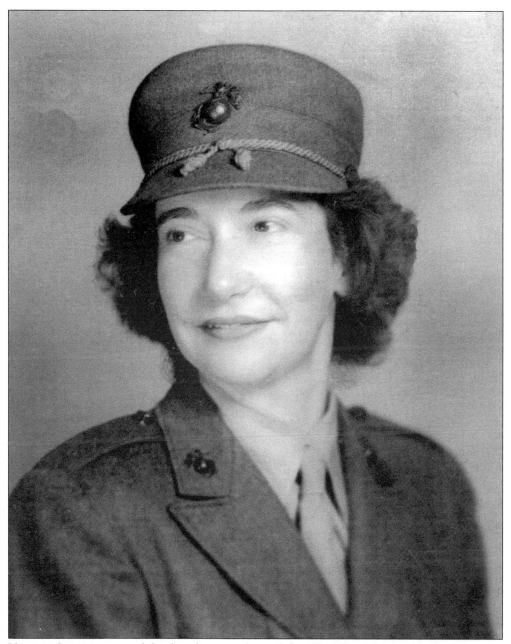

Virginia Seamans, one of the founding members of the West Sacramento Historical Society, was Marine Reservist Phoebe Virginia Shepherson from 1943 to 1945. During World War II she met and married Theodore (Ted) Seamans, who later became a beloved teacher and mentor to students at James Marshall High School. In her later years, she wrote a book of water exercises especially for adults battling osteoporosis, called *Ballet for the Bones*.

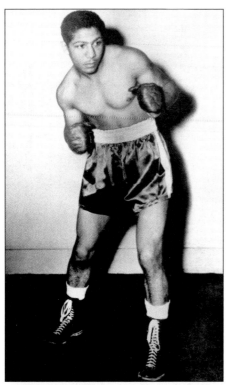

Joey Lopes, U.S. Professional Boxing Lightweight Champion contender, is pictured here on December 4, 1957. He fought professionally 92 times, with 62 wins, 24 losses, and 6 draws. He was in the ring with the greats of his day, among them Gabriel "Flash" Elorde, Joe Brown, and Sandy Saddler. Lopes was one of the great defensive fighters who always gave fans their money's worth when he fought.

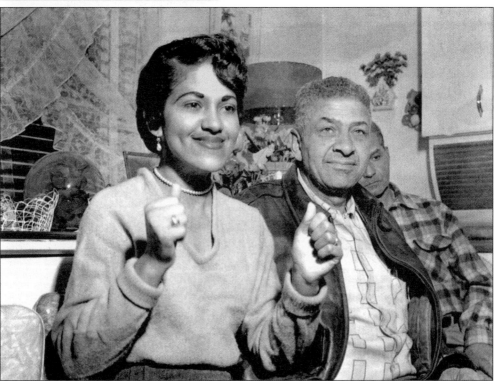

Joey's sister Jackie Lopes and their father, Joey Lopes Sr., watch boxing on television.

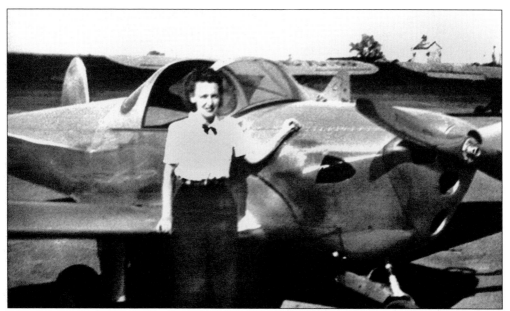

Pilot Louise Hughes is shown, in 1947, with the single-winged Air Coupe she flew at Capitol Sky Park. This busy airstrip was located next to the famous Capitol Inn on Davis Highway (now West Capitol Avenue), across the street from the Hotel El Rancho.

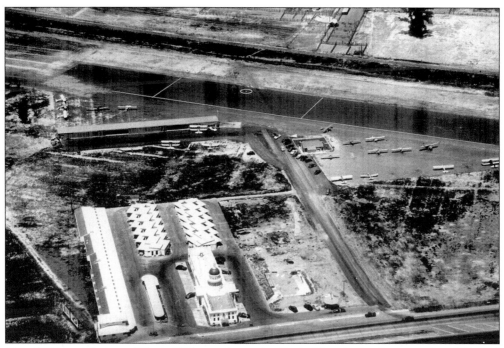

This 1950s aerial view of Davis Highway shows the Capitol Inn in the foreground and Capitol Sky Park in the background. According to historian Shipley Walters, "The airport had two runways, and could handle 66 small recreational, agricultural, and aerial survey planes. It served as the Downtown Sacramento Airport, and in the late 1950s it was the busiest private airport in the United States."

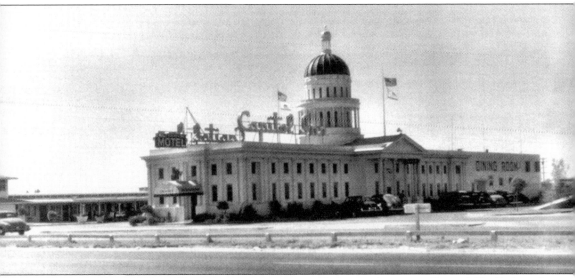

In the 1950s, this Capitol Inn was located on Davis Highway adjacent to Capitol Sky Park and across the highway from another well-known stopover, Hotel El Rancho. This luxury hotel was designed to replicate the state capitol building and was graced by a golden dome. Politicians and those doing business in Sacramento found this a comfortable and convenient place to stay.

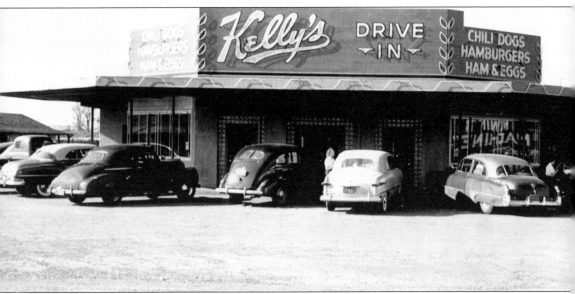

Kelly's Drive Inn was "the place to go" in the 1950s and 1960s. Excellent hamburgers, shakes, and cokes were served by carhops on trays that hooked onto the windows of cars. Besides eating in their cars, people roamed through the sea of autos, visiting with friends and acquaintances. Kelly's was the local gathering place, taking the place of the previous generation's social and fraternal clubs. Bandleader Kelly Perini and his wife, Paula, were the proprietors of this locally famous restaurant.

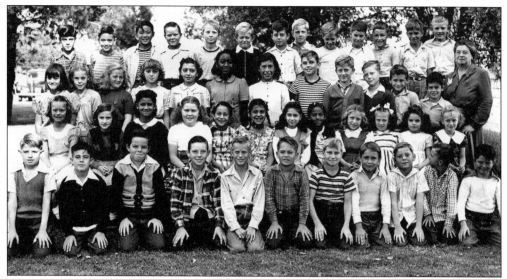

This photo shows Mrs. Ward's fourth-grade class at West Acres School in 1948. Large classes at all grade levels were common at that time, and this one had 48 students. From left to right are (front row) Stanley Travis, Kenny Valine, unidentified, Girand Smith, unidentified, Norman Grundon, Carry Elliot, unidentified, Jerry Moore, Roddy Harrison, and Jimmy Hight; (second row) two unidentified children, Joanne Vogt, Carol Bartley, Frida Mae West, Pearly Mae Nash, unidentified, Dale Harrington, unidentified, John Mills, and two unidentified children; (third row) Barbara Fudge, Marilyn Warren, Judy Lopez, Connie Smith, Lorraine Gomez, Carolyn Costa, Marie Coulombe, Jackie Lopes, Kathleen Edwards, Jeralyn Hughes, Joanne Brannon, and Janice Jones; (back row) Martin DeAnda, Chester Brookins, Nelson Akabori, unidentified, Richard Perrigo, Gene Davis, Tony Notis, James Perrigo, Tony McKay, Charles Lamarand, Robert Haney, unidentified, and Bobby Marcum.

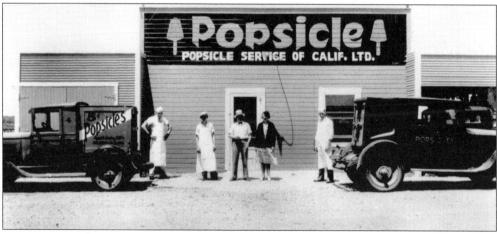

In 1928, Popsicle Service of California, a franchise of a Los Angeles company, was the only popsicle factory in Northern California and, at first, specialized in producing the "Alaska Sucker," a frozen treat on a stick. Soon, many kinds of popsicles were being made here for sale locally and as far away as Redding and Modesto, California, and Reno, Nevada. Until mobile refrigeration was possible, popsicles were packed in dry ice for shipping. Shown in the center of this photo are owners Eric and Jennie Hughes, with their son Max beside Eric. Two employees stand by the delivery trucks.

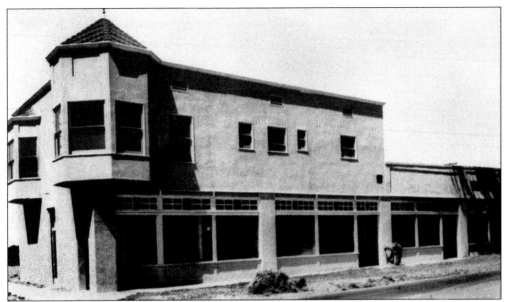

Doc Waite's building at the corner of Fifteenth Street and Virginia Avenue was perhaps the only two-story structure in the new town of West Sacramento in the 1920s through the 1940s. The family lived on the second floor, and the ground floor was devoted to Doc Waite's soft-drink bottling business. His specialty was root beer, but he also made and marketed flavorings for foods, beverages, and ice cream.

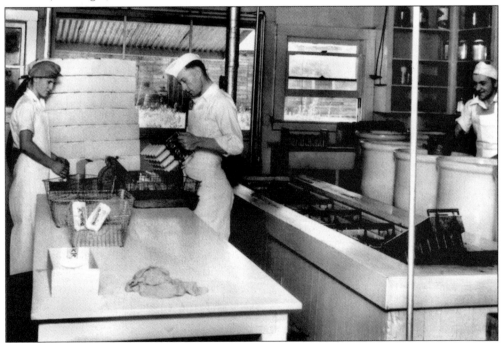

This photo shows popsicle production inside the Hughes Popsicle Plant in 1928. The worker (center) prepares to release the frozen popsicles into a basket, while Max Hughes (left) is involved in bagging the individual bars. The brine tank (center right) froze the mix (in vats at right) after it was hand-dipped into molds.

Born in 1927, Julius Feher is an important historical figure in West Sacramento. He began his newspaper career at age 11, and at the age of 15, he founded and began publishing the *West Sacramento News Reader*, which lasted for four years. Except for the actual printing, Feher published the six-page paper entirely by himself. In 1942, feature stories appeared about Feher and his venture in the *Sacramento Bee*, *Boys' Life*, the *Christian Science Monitor*, and in the nationally syndicated feature, "Ripley's Believe It or Not." In 1941, he edited the book *Eastern Yolo History*. Feher continued to publish a West Sacramento newspaper, the *News-Ledger*, until his death in 1988.

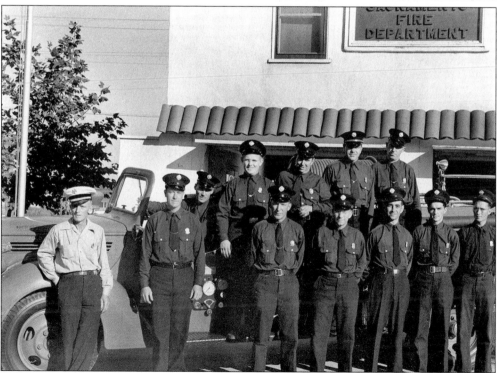

Cliff Travers, the fire department's first paid chief, poses with a new fire engine and some of the 20 volunteer firefighters he supervised. This photo was taken in front of the firehouse at Fifteenth Street and Alabama Avenue in 1942.

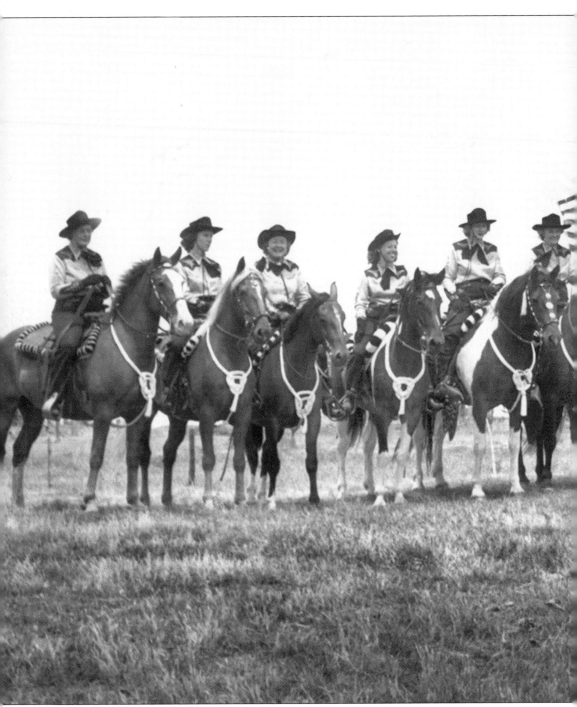

The Horsewomen's Association, pictured here in 1947, was an active group that participated in parades and events around the region, including the California State Fair. West Sacramento,

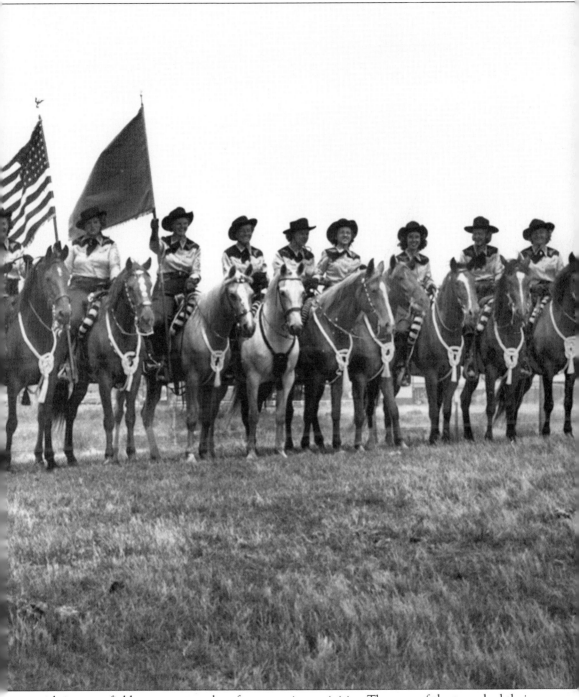

with its open fields, was a great place for equestrian activities. The men of the town had their own club and sometimes the groups merged for events. On the far left is Jennie Hughes.

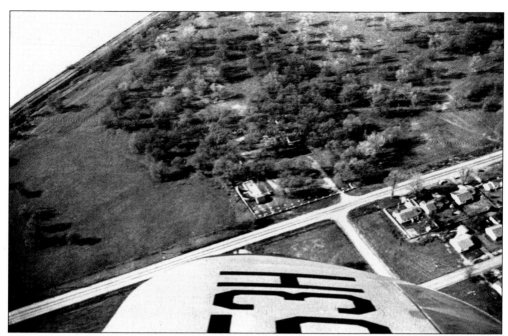

This aerial photo shows what the Westmore Oaks section of town looked like in 1947. The road, heading from left to right, is Park Boulevard, which at that time continued south to meet Jefferson Boulevard, before the Port of Sacramento cut through. In the middle of the photo, just above the wing tip, is now Acorn Circle.

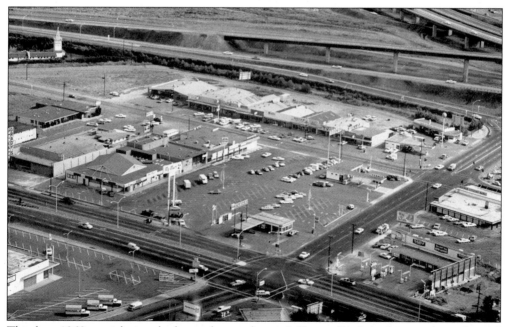

This late 1960s aerial view looks to the southeast. Jefferson Boulevard is on the right and intersects with West Capitol Avenue. The My Mart store, near the middle parking lot, is currently the site of a multi-store shopping center. In the upper left is the Hotel El Rancho.

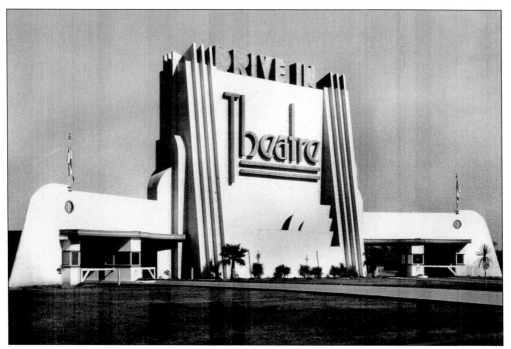

The El Rancho Drive-In Theater on West Capitol Avenue was a popular entertainment spot from 1940s to the 1970s. People drove their cars into the open-air theater, hooked a speaker onto a partially opened window, and settled down to enjoy the show.

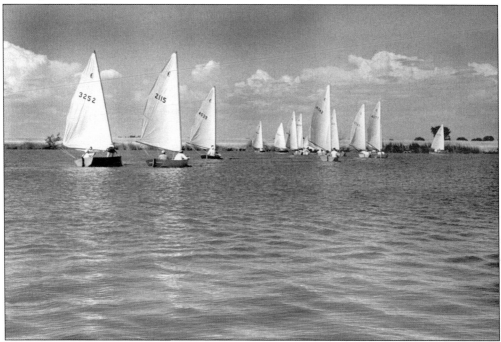

In 1957, the Penguin Invitational Regatta was held at Lake Washington. These small boats were just the right size for the lake. The Lake Washington Sailing Club is still active in 2004, although Lake Washington is now part of the turning basin of the Port of Sacramento.

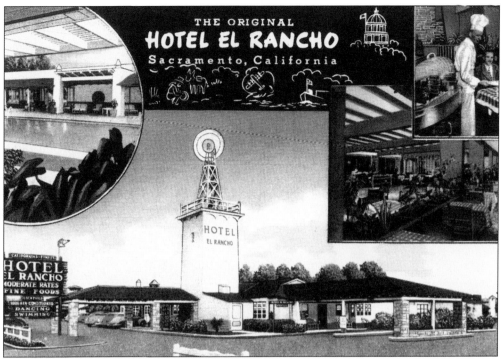

Hotel El Rancho was a celebrity stop from the 1940s until the 1970s. Guests could fly into the Capitol Sky Park across Davis Highway or drive up U.S. Highway 40 (Lincoln Highway) to reach the hotel's luxurious accommodations and get to California's capital, just a few minutes away, over the Tower Bridge.

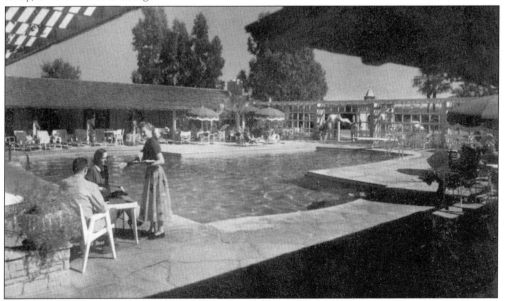

Hotel El Rancho's well-appointed swimming pool and outdoor dining area were popular during the searing summer weather before air-conditioning was widely available. The hotel's restaurant, bar, and convention center hosted many local events before the hotel's closure. In 2004, the site is home to the City of Dharma Realm, a Buddhist women's monastery.

This three-wheeled ice cream vendor cart was a common sight on the streets of West Sacramento during the 1950s. These vendors were the only direct retail outlet for Hughes Frozen Confections. The sign announcing Chism lets customers know that the very rich and delicious Reno, Nevada ice cream product was available at their door.

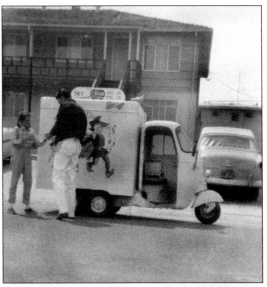

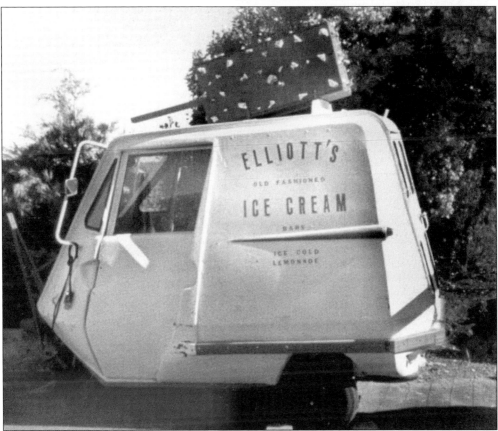

Elliott's Ice Cream operated in the 1970s. A specialized machine cut a half-gallon brick of ice cream into 12 bars, and sticks were inserted for easy handling. The bars were then hand-dipped in chocolate and rolled in nuts. This vending trailer moved around the community to serve customers.

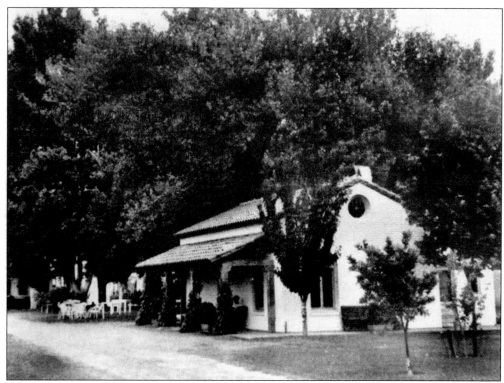

Schaffnit's Lodge was located on South River Road between Tower Bridge and Fifteenth Street. This tree-shaded park, which included a clubhouse and swimming pool, was a popular place for private parties before it was demolished in the 1960s to make way for the freeway.

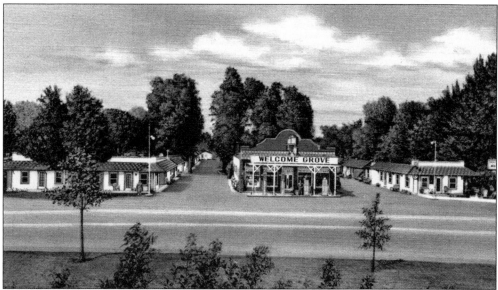

This 1930s postcard advertises the Welcome Grove Auto Court and Trailer Park on Davis Highway, within a quarter-mile of the Tower Bridge across the Sacramento River. The Welcome Grove is still in operation in 2004, but the buildings have been modernized. The grove of trees continues to shade the park-like setting.

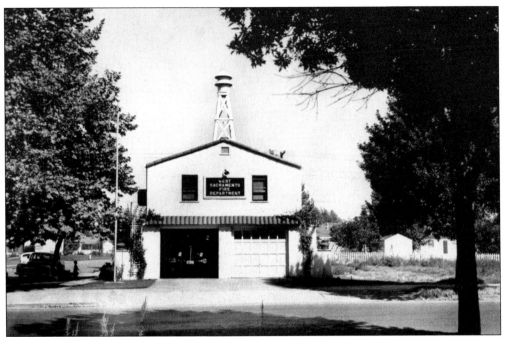

Pictured here is the original firehouse, built in 1939 at Fifteenth Street and Alabama Avenue. E.C. Hughes, chairman of the board, arranged with Knox Lumber Company in Sacramento to furnish all the building materials for the firehouse in consideration of a personal note signed by each of the members of the board. This was done, and the male residents in town also came to the rescue, providing the free labor. A large bell was then donated by Southern Pacific to call the volunteers in the event of a fire. This is the only original fire station still in operation in West Sacramento.

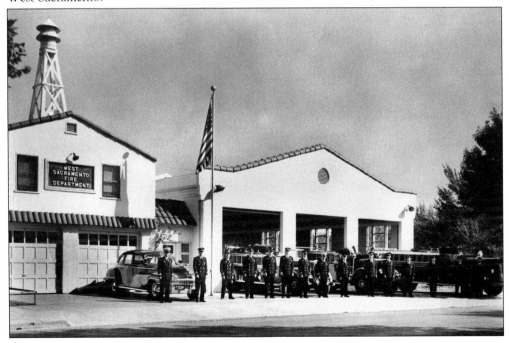

In 1976, Supervisor Art Edmonds dedicated the new Arthur Turner Library on Merkley Avenue. Mr. and Mrs. Turner donated the land for the library. Arthur Turner was originally hired by the developers of West Sacramento as a bookkeeper, but he soon became West Sacramento's greatest advocate. The new library met every need at the time and even boasted a stained-glass window designed and installed by local artist Betty Fairbairn Sokolich.

The East Yolo Friends of the Library raises funds by selling used books. In this photo, Grace Ohlson and other members prepare for the annual event. Book sales have made possible the purchase of many new books not funded by the budget.

In the 1940s, the West Acres Community Church met at this modest site at the corner of West Acres Road and Evergreen Avenue. The church was well attended by young families in the area. It sponsored pageants and ice cream socials as well as regular worship services. Soon the congregation outgrew this small building and a building fund was organized to erect a new structure.

The outcome of the building project in the 1950s was Trinity Presbyterian Church on Park Boulevard at West Acres Road. Church members contributed money and labor to the construction of their permanent home. Stained-glass artwork was commissioned from artist Betty Fairbairn Sokolich.

Crest Jewelers, owned by the Macias family, began its watch repair and jewelry sales in 1967 on Merkely Avenue, then moved to West Capitol Avenue. The family-operated business near Safeway still serves the community.

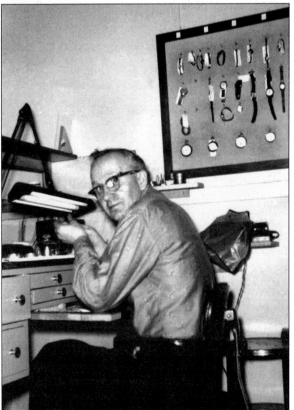

Marvin Schirmer took over this watch repair and jewelry business in Farmco from Woody Hensley in 1967. He also operated a concession in the Farmer's Market in Sacramento. Rasco Tempo stores took over Farmco, but Schirmer continued his business at this same site. In 1972, he moved to Ione, California, where he operated a jewelry store and watch repair shop there until his death in 1973.

Willie DaPrato bought a small grocery store near the corner of Fifteenth Street and Virginia Avenue in the late 1940s. In 1958, he opened a supermarket on the same property. Willie was an active member of the community. His market sponsored Easter egg hunts, a bowling team, and Halloween festivities. It also gave a bike to a lucky child, and invited Santa Claus at Christmastime. Since Willie's retirement, the market has changed hands and, in 2004, is known as Fifteenth Street Market.

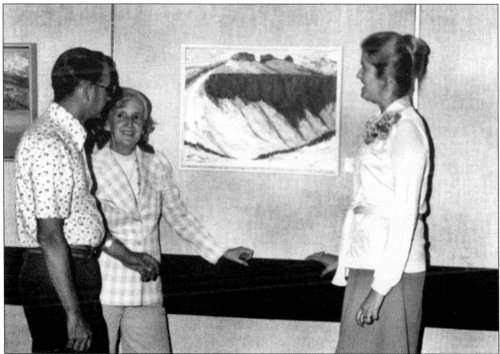

Joan Leeds discusses a painting at an art exhibit in the Turner Library Community Room in the 1980s. A local artists group maintains continuous showings there for the public to enjoy.

The West Sacramento Folk Dance Club was very active in the late 1940s and 1950s and met at the West Sacramento Community Clubhouse on Alameda Avenue at Delaware Avenue. The club participated in local and regional events, including the California State Fair.

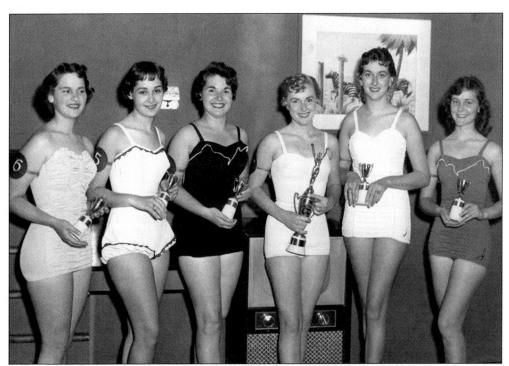

In 1955 these West Sacramento teenagers competed for the title of "Miss West Sacramento" and a chance to compete in the county-wide contest for the title of "Sugar Queen" at the Yolo County Fair. Each contestant appeared in a bathing suit and also formal wear. These contests drew crowds for the lunchtime events held at the El Rancho or the Capitol Inn. Pictured are Jackie Silva, second from left, and Arlene Perini, second from right.

This regionally famous racecourse, located on West Capitol Avenue in the 1950s through the 1980s, was once owned by V.C. (Mac) and Phoebe McGowan, the parents of Supervisor Mike McGowan. Over the years, the track was known by several names and had different owners. At first, it was called Sacramento Raceway, then Capitol (and Capital) Speedway. After 1971, it became West Capitol Raceway.

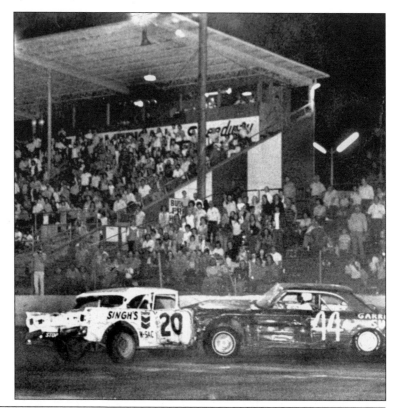

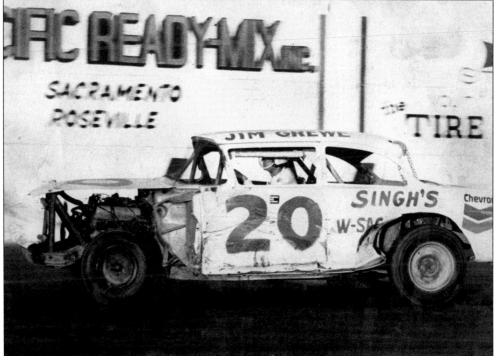

This famous car and its driver, Jim Grewe, were often seen racing at West Capitol Raceway.

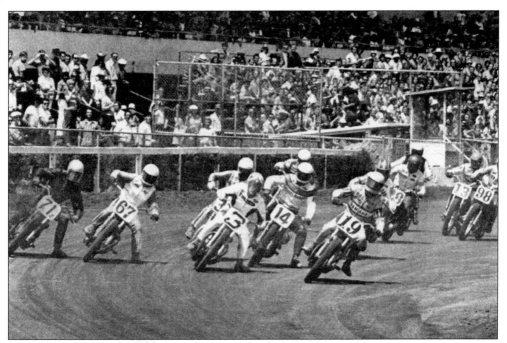

West Capitol Raceway hosted motorcycle races on its professional half-mile dirt track. All the big names in racing came here to compete.

Capt. Ron Bertsch chauffeurs city council members at the celebration of the opening of the Kegle Drive underpass. With this new connector, the City of West Sacramento created a powerful new tool for blending the communities north and south of the railroad tracks.

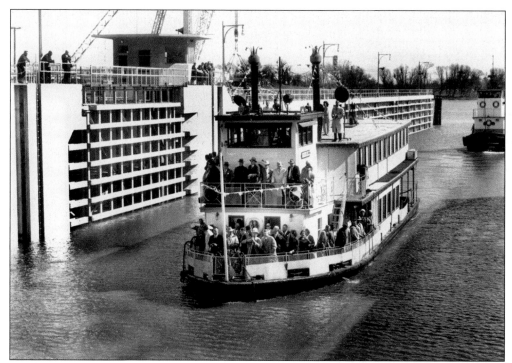

On June 29, 1963, the Port of Sacramento celebrated its completion. The three-day program of activities, which drew 75,000 attendees, included trips through the locks between the Sacramento River and the ship turning basin. Other highlights included parades, navy vessels, and the California Maritime Academy's Golden Bear cadet training ship.

This early aerial photo of the Port of Sacramento shows the deep-water channel cutting diagonally across the photo. The locks that separate the Sacramento River from the channel appear on the right side of the bridge at the upper right corner. The docks and the ship turning basin would be to the left of this photo.

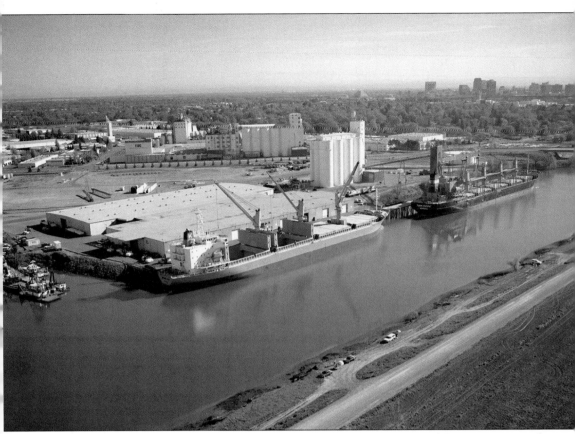

This is 2004 aerial view of the Port of Sacramento shows the area west of that appearing in the previous photograph. The docks and warehouses are in the center, with tugboat storage to the left and the Palamidessi Bridge to the right. The skyline of Sacramento is visible in the top right corner.

STOP CITY TAXES

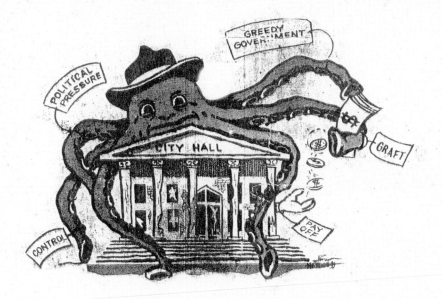

VOTE NO!

EAST YOLO INCORPORATION
NOVEMBER 5th, 1968

In 1968, East Yolo citizens attempted to get voter approval for incorporation. However, many wanted the local communities to remain separate, served by many districts for fire protection, sewers, and county sheriff protection. The opponents won the day, using posters like this to encourage those who opposed the change to vote NO. Eventually, in 1987, incorporation won, and now the proud city of West Sacramento serves all the area communities and unites them to plan for the future together.

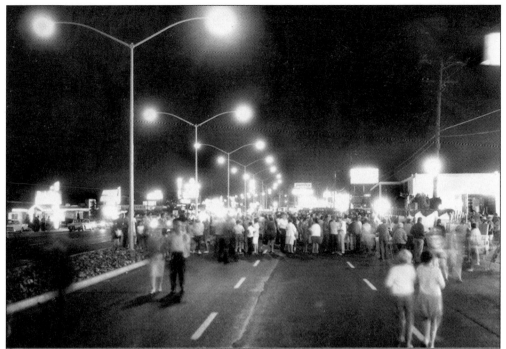

This photo shows an after-dark celebration on West Capitol Avenue (date unknown). Traffic was blocked off from the area and the entire community joined in the fun.

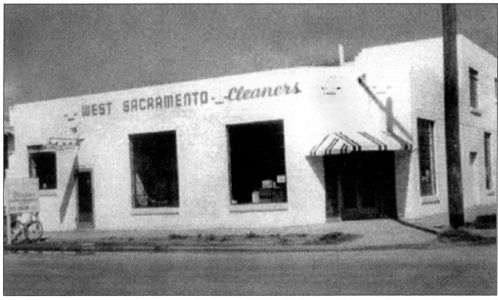

The West Sacramento Cleaners was built in 1946 by Hubert and Grace Beers at the corner of Fifteenth Street and Virginia Avenue. At first, the actual cleaning was done by another cleaners and only "spotting" (taking out stains that didn't come out in the first process) and pressing were done here. A small restaurant occupied the western portion of the building, and when it moved out, dry-cleaning equipment was installed in that area and Beers became a full-service cleaners until 1971, when the widowed Mrs. Beers retired and sold the building.

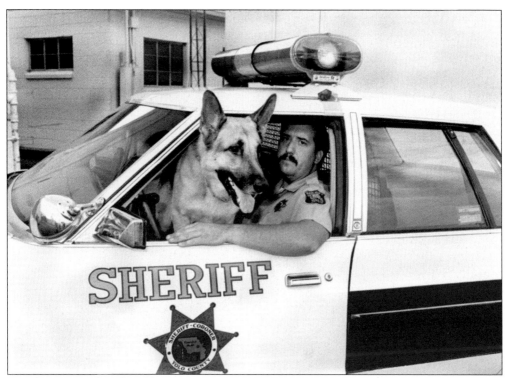

A Yolo County sheriff and his canine support pose for this photograph prior to incorporation. In 2004, the West Sacramento Police Department had a K9 unit consisting of three officers and their dogs.

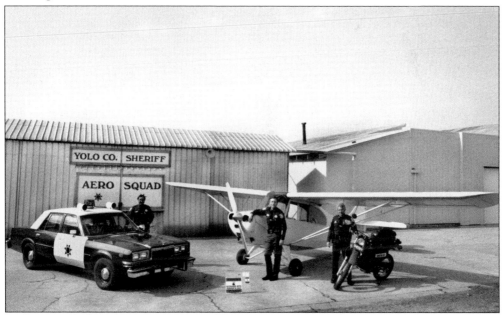

In the years before the communities of East Yolo incorporated to become the City of West Sacramento, laws were enforced by Yolo County sheriffs. Here, officers stand with equipment they used to patrol the area: a squad car, an airplane, and a motorcycle.

In the 1960s and 1970s, Gurney and Mabel Bingaman, and their dog Rusty, lived on Circle Street in a home overlooking the stately oak grove in Circle Park. This park was part of the West Sacramento Company's 1911 vision of the new town and was featured on the front page of its original sales brochure.

Is this board bored? The candid photo is not labeled, but the ledger on the table in front of Eric Hughes suggests it is a board meeting, probably in the 1950s.

In this undated photo, Ken Brown, music director at River City High School for many years, leads the chorus in a program of Christmas songs.

The James Marshall High School drill team participates in a Community Day parade at West Acre and Merkeley Avenues, c. 1970.

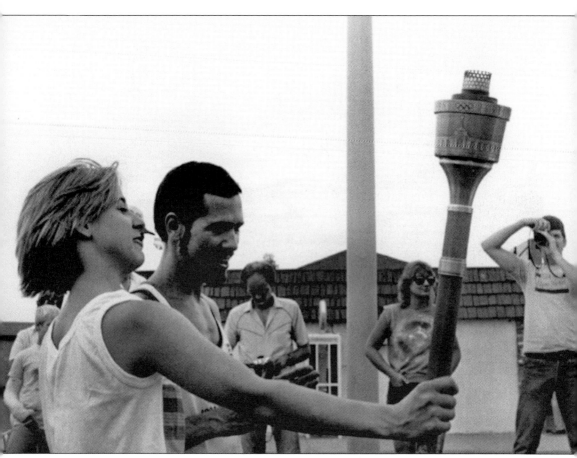

The Olympic Torch has been carried down West Capitol Avenue many times to announce the coming Olympic events. Runners carry the torch for quarter-mile segments. This photo, showing the passing of the torch in West Sacramento, was probably taken in the 1980s because the torch is in the old style, much heavier than those used in 2004.

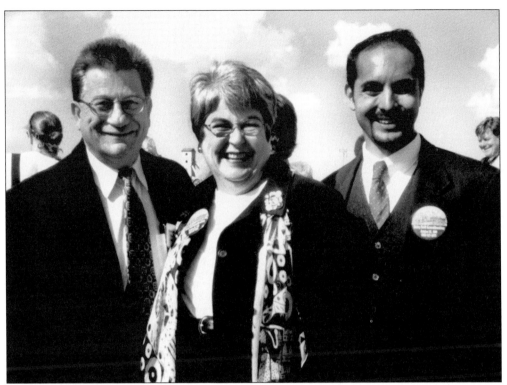

Local dignitaries, from left to right, Yolo County supervisor Mike McGowan, Assemblywoman Helen Thomson, and West Sacramento mayor Christopher Cabaldon celebrate the groundbreaking for Raley Field in 1998. Home to the Pacific Coast League AAA River Cats baseball team, this stadium has become a major attraction for the region.

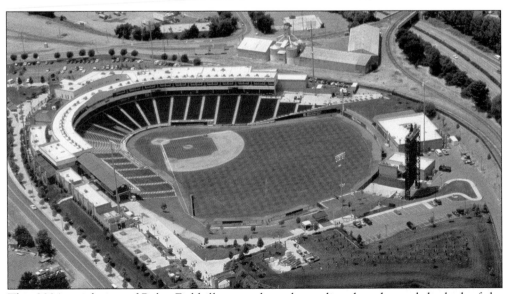

This 2004 aerial view of Raley Field illustrates how the stadium has changed the look of the riverfront area. Previously an industrial section, the area is now a bright jewel with beautiful landscaping, a new street, and people having fun.

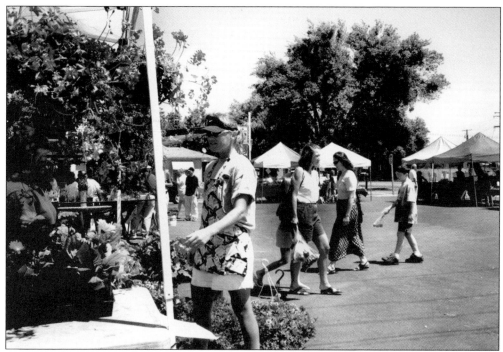

In 2004, an open-air, certified organic farmers market began operating on Sunday mornings during the summer at the corner of Fifteenth Street and Jefferson Boulevard in the parking lot of Whitey's Jolly Kone. Local farmers sell fresh fruits, vegetables, flowers, and plants, including organically grown edibles. A bakery sets up shop and a kettle-corn maker fills the air with delicious aromas.

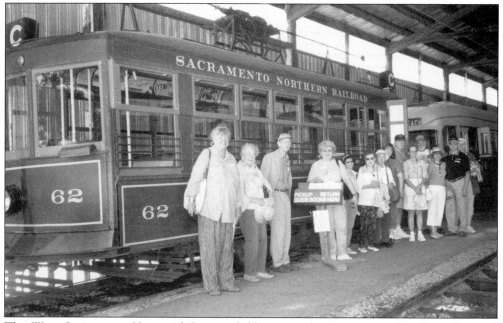

The West Sacramento Historical Society field trip to the Sacramento Northern Railroad Museum in 2000 included a ride on an old train.

Five
SOUTHPORT

While agriculture and Reclamation District (RD) 900 were predominant in the southern area, Arlington Oaks, Linden Acres, and Touchstone Condominiums were home to many suburban families. The county board of supervisors officially designated Southport a town on January 12, 1970. Today, development of new homes and a new shopping mall are slowly replacing farmland.

This view of crops in a field near the levee faces north along the Sacramento River. Note the dredger on the right.

How high does wheat grow? This is one of the original advertisements for the West Sacramento Land Company Project.

Haystacks are ready for bailing in West Sacramento along the Sacramento River.

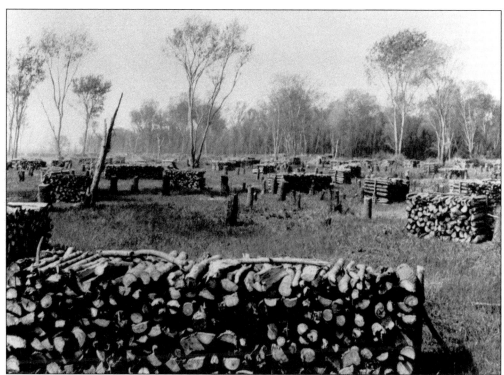

Wood piles are ready for removal to allow for the development of the turn-of-the-century West Sacramento Land Company Project.

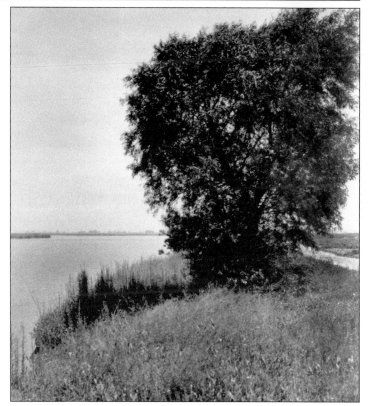

A typical view from the bank of Lake Washington in 1913.

The West Sacramento Company built this structure in 1911 as an agricultural soil-testing station. Later, it became the Hideaway Club, a sandwich shop that also served beverages of all kinds, including alcohol during the years of Prohibition from 1919 to 1933.

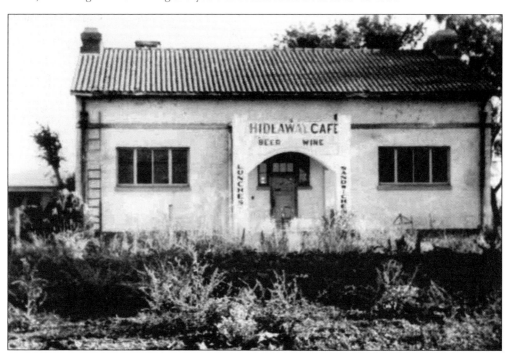

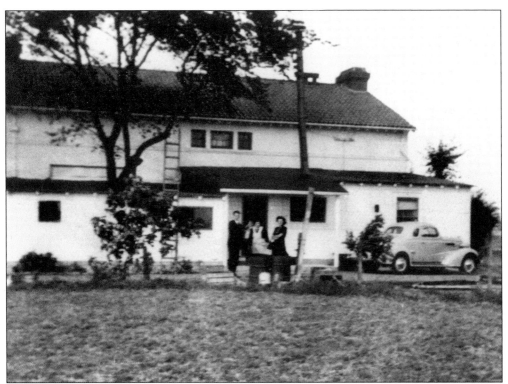

In 1935, George and Louisa Palamidessi bought the Hideaway and added a restaurant they called Club Pheasant. It continues to be family-owned and operated in 2004, and is regionally famous. It still uses Louisa's delicious recipes.

This Catholic Mission church was located at Gregory and Jefferson Boulevard, but it may have been moved to this site because it is sitting on wooden piers. The date of this photo is unknown.

Although much of Southport is being developed for commercial and residential purposes, agriculture is still noticeable in the area. However, the high cost of farming has resulted in

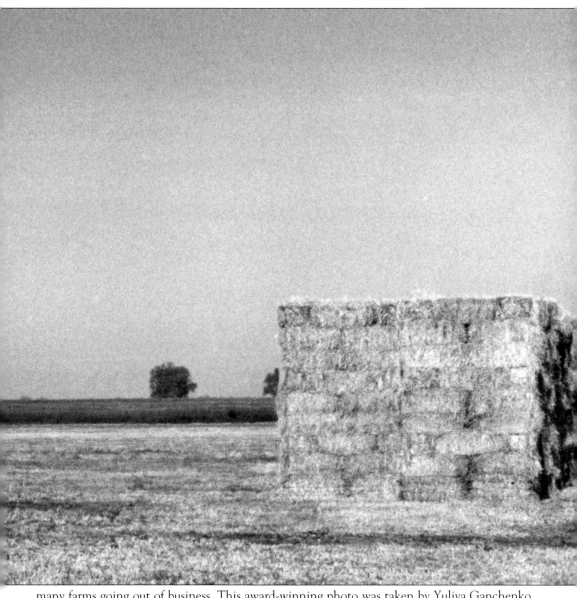

many farms going out of business. This award-winning photo was taken by Yuliya Ganchenko in 2003. (Courtesy of the City of West Sacramento.)

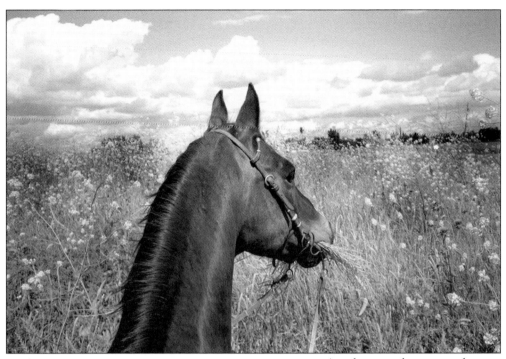

Another award-winning photo shows a horse enjoying a mouthful of mustard. Mustard fields are a common sight in the spring of the year. (Courtesy of the City of West Sacramento and Debi Earl.)

The demand for housing is slowly encroaching upon the area's remaining open space. Due to its proximity to San Francisco and the surrounding Bay Area, as well as good housing prices, West Sacramento is very attractive to home buyers. The city's population is expected to double in the next 20 years.

Six
City of West Sacramento

West Sacramento incorporated as a city in 1987 and, since that time, has been termed a "premier city of the region." Primarily a community built on agriculture, industry, and residential forces, West Sacramento has slowly grown in population to over 34,000 residents. Progress has added new schools, improved sewer and road infrastructure, provided additional city parks, attracted new businesses, acquired a Pacific Coast League AAA minor league baseball team, and provided affordable housing to new residents. This has contributed to making West Sacramento an ideal place to raise a family.

Several years ago, the city began sponsoring a photo contest during 15 days in the month of May. Some of the past winning entries are shown and noted throughout this book and in this final chapter.

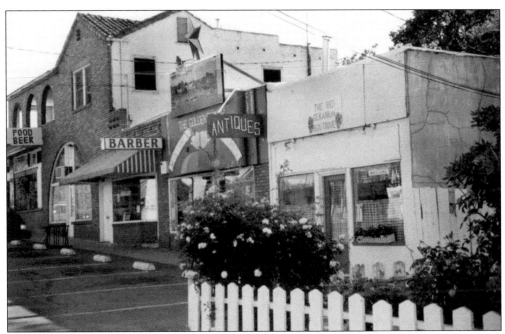

These storefronts on Third and C Streets in Broderick include the following businesses, from left to right: the Bridgeview Market, the Sail Shop, Golden Poppy Antiques, and a vacant building. This complex, built in the 1920s, is one of the earliest remaining in West Sacramento, and the Bridgeview Market is the only business still in operation. Currently, the site is being remodeled to attract other businesses. This photo was taken in the 1990s.

This roast, featuring West Sacramento's first mayor, Mike McGowan, was presented by Soroptimist International of West Sacramento (SIWS) on January 9, 1988. SIWS president Josie Andre is pictured here with Mike McGowan and Willie DaPrato at the event. The fundraiser provided the money for the city seal, which hangs in the council chambers of West Sacramento's Civic Center and is pictured below during its 2003 installation.

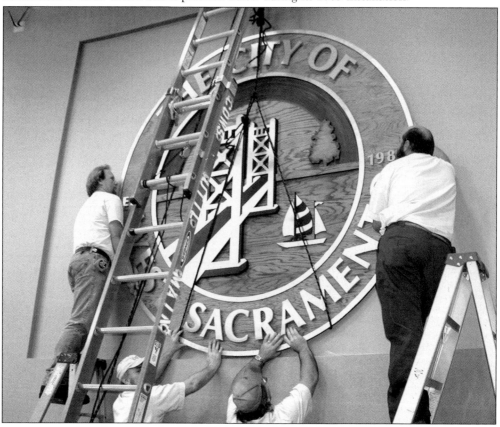

This view, looking east from Fourth and D Streets, shows the location of the new Metro Place at Washington Square single-family housing units. The buildings in the background, beyond the trees, are part of the City of Sacramento.

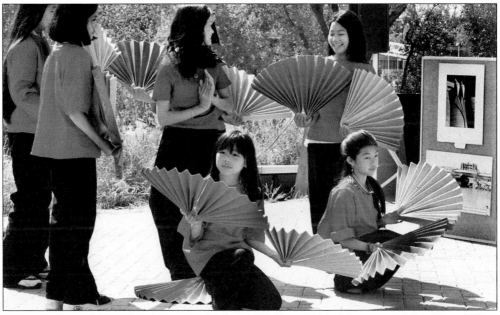

Asian youth perform a fan dance on the River Walk in 1999. (Courtesy of the City of West Sacramento and Mary Silva.)

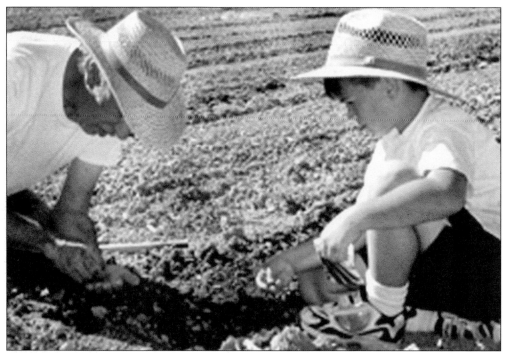

"Planting Grandpa's Garden," 2002. (Courtesy of the City of West Sacramento and Anne M. Gabri.)

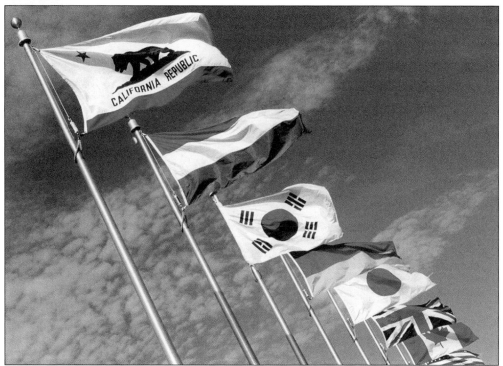

"Flags of Many Nations, California Fuel Cell Partnership," 2001. (Courtesy of the City of West Sacramento and Wanda Schubert.)

"Best Chef in the West," 2004.
(Courtesy of the City of West
Sacramento and Betty Mitchell.)

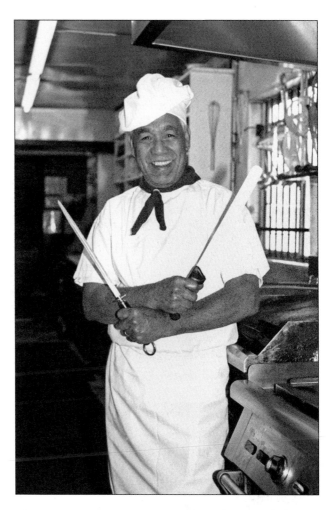

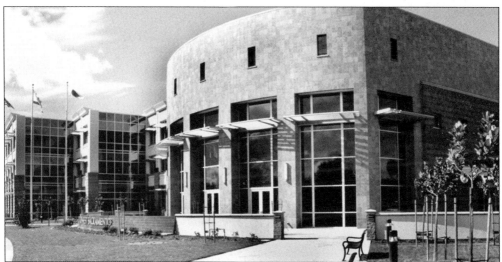

This is the West Sacramento Civic Center in 2003. (Courtesy of the City of West Sacramento.)

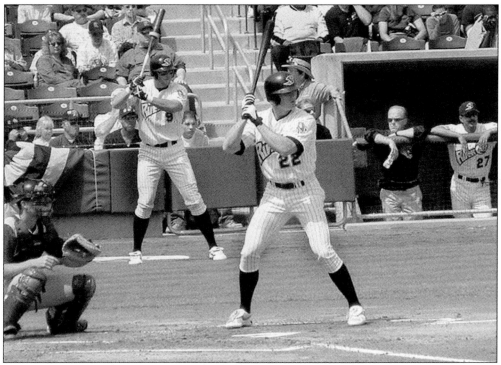

"Eric [Burns] at the Bat," 2001. (Courtesy of the City of West Sacramento and Loretta Robben-Pinto.)

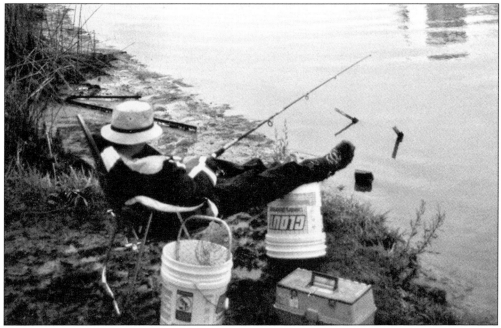

Fishing is a favorite recreational activity along the river and port area, as demonstrated here in 2000. (Courtesy of the City of West Sacramento and Gary Clements.)

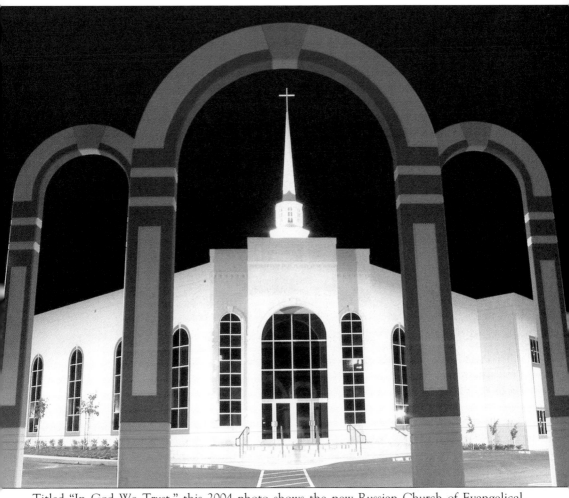

Titled "In God We Trust," this 2004 photo shows the new Russian Church of Evangelical Christian Baptists. (Courtesy of the City of West Sacramento and Yusup Adzhiev.)

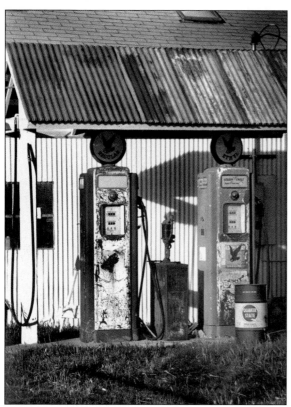

"Out of Gas, Senator Garage," 2001. (Courtesy of the City of West Sacramento and Pat Anderson.)

Members of the West Sacramento Historical Society enjoy the annual July barbecue at Lake Washington in 2002.

"Stairs, South River Road," 2001. (Courtesy of the City of West Sacramento and Leland Wong.)

This 2002 photo shows strawberry fields off Jefferson Boulevard in the Southport area. (Courtesy of the City of West Sacramento and Patrice Jansen.)

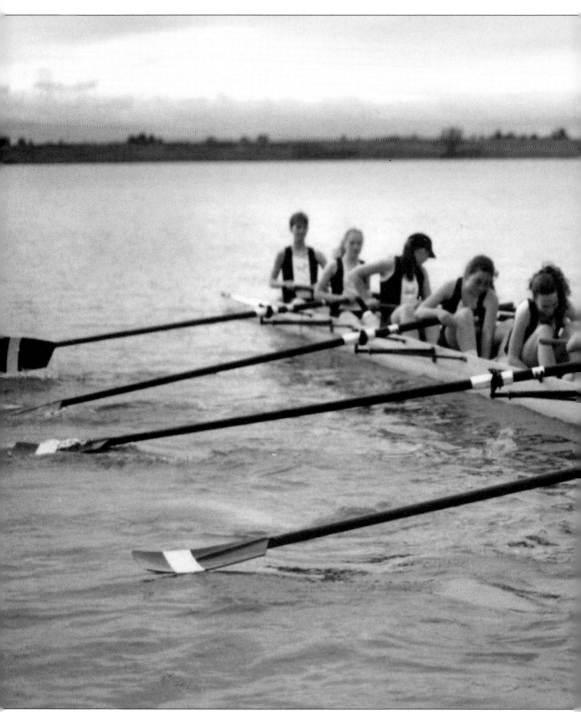

This 2000 photo features the River City Rowing Club on Lake Washington near the ship-

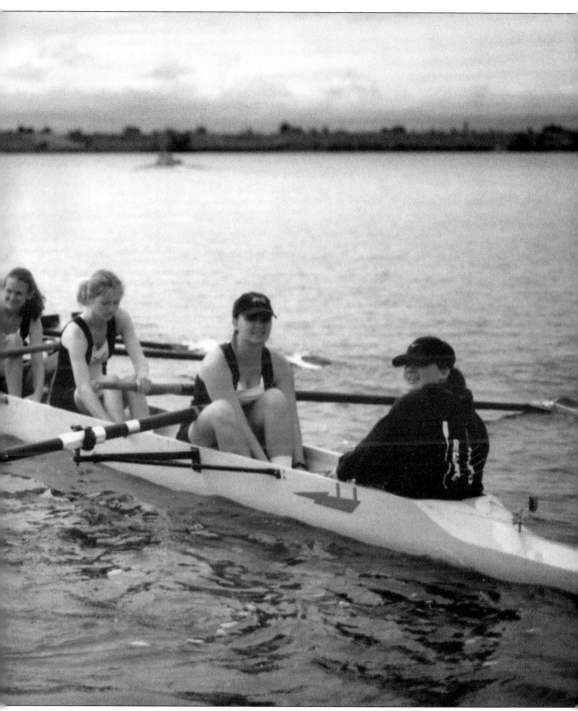

turning basin. (Courtesy of the City of West Sacramento and Andrea D. Morgan.)

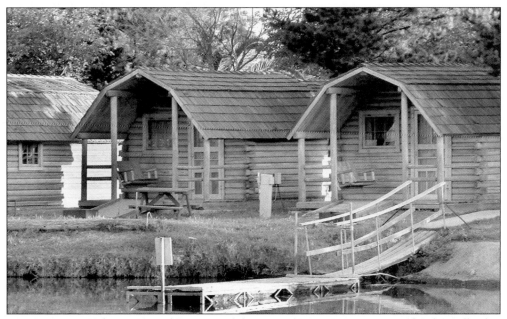

"KOA Kampin Kabins," 2001. (Courtesy of the City of West Sacramento and Bob Medley.)

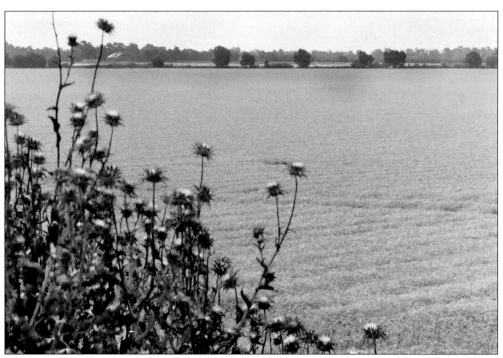

This wheat field is situated along the Sacramento River, near Elkhorn Station, in 2004.

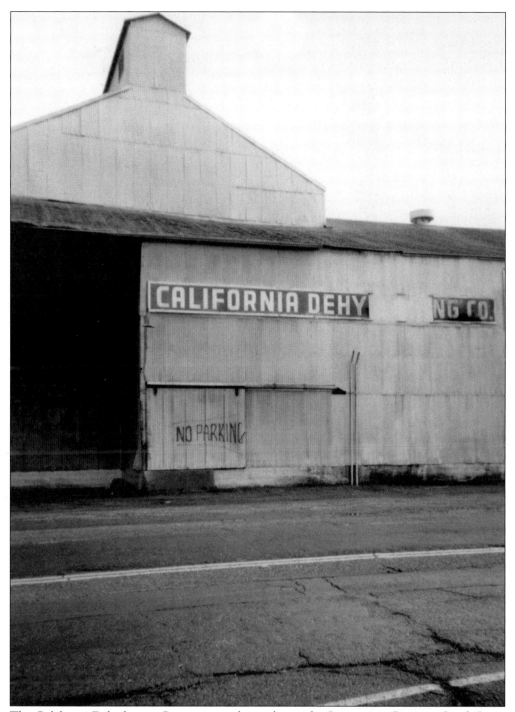

The California Dehydrating Company was located near the Sacramento River on South River Road and Tower Bridge, across from Raley's Field. Built in the 1920s, this building served the agricultural community. In 2004, this site is being cleared for redevelopment.

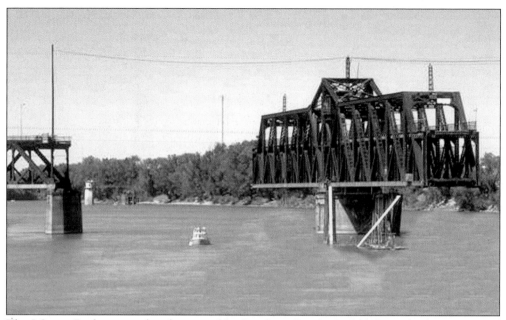

The I Street Bridge, owned and operated by Southern Pacific Railroad, was built in 1911 and still pivots open to allow boat traffic on the Sacramento River. The two white masts in the foreground are the remains of a sailboat that wasn't so lucky during one of the floods.

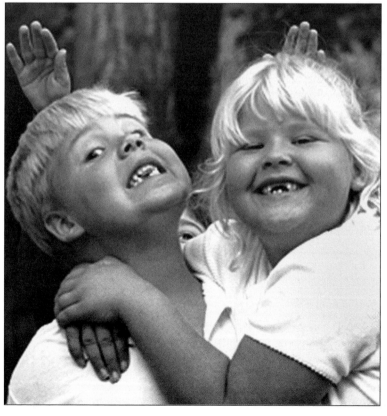

Titled "Twins," this photo captures fun-loving youth and West Sacramento's future. (Courtesy of the City of West Sacramento and Fanny Staps.)

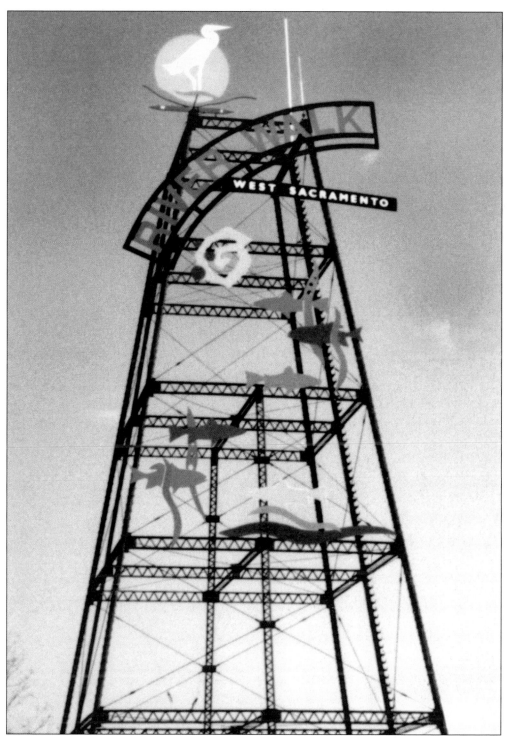

Located in Broderick, this River Walk sign has become a landmark. The tower structure was part of early Washington and was remodeled in 2000 to identify the new River Walk park area, the latest development along the waterfront.

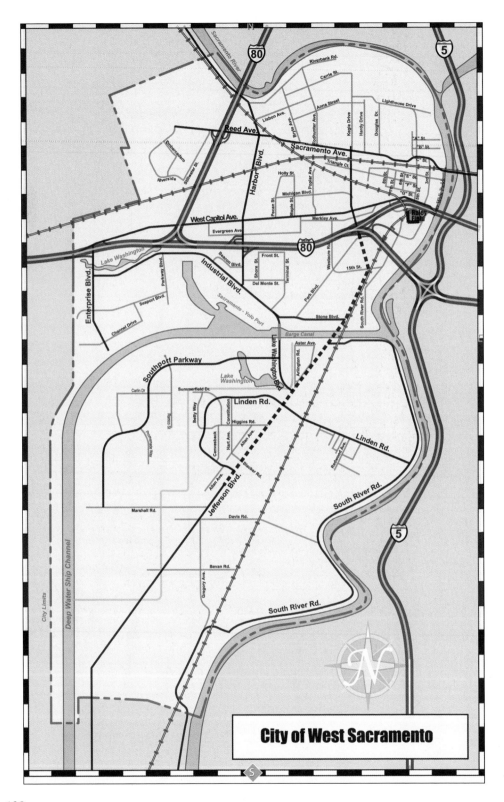

City of West Sacramento